WEST HIGHLAND LINE

JOHN McGREGOR

AMBERLEY PUBLISHING

For Malcolm and Kirsten

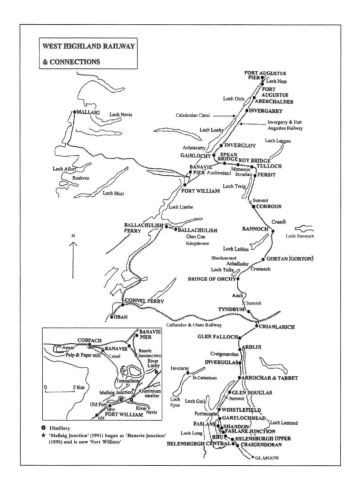

First published 2013

Amberley Publishing
The Hill, Stroud
Gloucestershire, GL5 4EP

www.amberley-books.com

Copyright © John McGregor, 2013

The right of John McGregor to be identified as the
Author of this work has been asserted in accordance
with the Copyrights, Designs and Patents Act 1988.

ISBN 978 1 4456 1336 9
E-BOOK ISBN 978 1 4456 1348 2

British Library Cataloguing in Publication Data.
A catalogue record for this book is available from
the British Library.

Typeset in 9.5pt on 12pt Celeste.
Typesetting by Amberley Publishing.
Printed in the UK.

Introduction

At the margin of memory, in the first years of British Railways, I recall an arriving train, still in LNER 'teak', with Glasgow–Mallaig and Kings Cross–Fort William roof-boards; a 'Banavie Boat' destination indicator, redundant since 1939; a grubby green K2 at Fort William pierhead; and a pristine black K1 on shed. The West Highland was then some fifty-five years in being, the Mallaig Extension not quite half a century old, the Invergarry & Fort Augustus just dismantled ... Another six decades have passed. Fort William's 'new station' has seen nearly forty years of use, and Sprinter DMUs have served for more than half that period. 'Heritage steam' is securely established, and preserved diesel veterans pay frequent visits.

My picture history, with its companion on the Banavie branch and the Mallaig Extension, captures something of this twelve-decade span. I have excluded Glasgow Eastfield shed. The I&FA's is a complex and cautionary tale, cursorily treated. Though rarities appear, there are omissions – notably the D11 'Scottish Director' 4-4-0s as West Highland pilots and the K3s known to have reached Crianlarich.

The prospect of an early railway through the Highlands to Inverness by a western route soon faded as the 1840s 'Mania' subsided. Inverness would achieve a tenuous link with the south via Aberdeen (1858), and then a through route to Perth by Spey and Tay (1863). The several Inverness companies would amalgamate into the Highland Railway (1865); and the Highland's over-the-Grampians main line, together with the already-established line from Carlisle across Scotland's Central Belt, would become the artery of the north.

The western Highlands eventually achieved cross-country connection with the Stirling–Perth–Inverness trunk route. Though the proposed 'Fort William Railway' (1863) – from Strathspey into Lochaber and perhaps westward to the coast – did not proceed, the Dingwall & Skye Railway reached Strome Ferry in 1870 (and was gathered into the Highland Company ten years later). The Callander & Oban Railway, built in stages, was completed by 1880. Beginning under the wing of the Scottish Central Company, the Callander & Oban became, in Scotland's 'great amalgamations' of 1864–6, the client of the powerful Caledonian Railway.

For the North British Company, hitherto Edinburgh-centred, the best prize (1865) was the Edinburgh & Glasgow Railway, which had unfulfilled ambitions in the west. Throughout the 1870s and 1880s, Caledonian and North British remained at war, the latter

kept on the defensive by a bits-and-pieces system, at last united (1890) by the great bridges across Forth and Tay. When the North British first looked seriously beyond their railheads at Helensburgh, Balloch and Aberfoyle, it was to support the Clyde, Ardrishaig & Crinan Railway, authorised in 1887 but wound up in 1892. And similar terms (a North British guarantee and working agreement) were offered to the more promising West Highland Railway, approved in 1889 and opened to Fort William in 1894.

The West Highland would create a cut-off route to Oban via Helensburgh and Crianlarich, and the North British aimed covertly at Oban besides Fort William. In backing the West Highland, the North British sought to preserve their north Clydeside and Loch Lomond traffic from Caledonian incursion (which nevertheless materialised in the Lanarkshire & Dumbartonshire Railway). The prospect of state assistance was another factor, after the Napier Commission (1883–4) had recommended a third railway harbour (in addition to Oban and Strome Ferry) on the remote west coast. At first, however, the North British did not pledge to carry the West Highland beyond Fort William. And for this reason, besides landowner opposition, the promoters' proposed 30-mile extension to Roshven on Loch Ailort was struck from the West Highland Bill.

Poorly served districts like Lochaber were eager for rail connection, while engineers and contractors were ready with new schemes to draw in established companies. For Formans & McCall, who engineered the West Highland, and Lucas & Aird, who built the line, it was at bottom a speculative venture. Though northern Scotland seems unpromising territory for such activity, opportunities elsewhere in Britain were diminishing. North British support for the West Highland was certainly prompted by the grandiose and blatantly speculative 'Glasgow & North Western Railway' of 1882–3; its proposed route to Inverness, via Loch Lomond, Glen Coe and the Great Glen, had set Caledonian against North British and both of them against the Highland Company.

Railway projects multiplied across the Highlands in the 1890s – some practical, some unrealistically ambitious, and altogether a curious echo of the classic 'Mania' half a century earlier. Proposed additions to the West Highland included a funicular at Portincaple on Loch Long, with ferry connection to Loch Goil; the Loch Fyne Light Railway from Arrochar & Tarbet to St Catherine's (for Inveraray); and a link from Glen Spean to the Highland Railway and the Great North of Scotland in Strathspey. The North British, whatever their first intentions, grew wary of multiplying commitments. In 1895 the Callander & Oban and West Highland drew a frontier at Ballachulish. It was a telling moment, and an expression of the détente which their two patrons, Caledonian and North British, had begun to seek. The Highlands were not to enjoy a unified railway system; instead, three protagonists (Highland, Caledonian and North British latecomer) would consolidate their respective territories. And three distinct but wandering routes to the west coast would survive both Grouping and Nationalisation.

Building the West Highland was costly, prolonged by a dispute with Lucas & Aird. The North British intervened to rescue their protégé – when North British 'second thoughts' may well have begun. The West Highland Ballachulish Extension, authorised in 1896, remained unbuilt. At Crianlarich, where the West Highland intersected the Callander & Oban, a spur came into use from 1897; but the North British, when denied running powers to Oban, showed small enthusiasm for exchange of traffic. The much delayed and controversial (because state-aided) Mallaig Extension, which opened in 1901,

sank in North British estimation to a needs-must expedient. With a government guarantee in place and the Caledonian persuaded not to oppose or interfere, the contributory traffic of the Mallaig line would relieve (but never eliminate) the burden which the West Highland had become.

Unable to win a larger share of through traffic via Perth, the North British certainly weighed the possibility of a new western route to Inverness; and the Highland Company were vulnerable until the Aviemore cut-off (authorised in 1884 but not completed until 1898) shortened their Perth–Inverness main line. But the Great Glen Agreement of 1889 (the so-called Ten Years Truce), whereby the Highland ceased to oppose the West Highland Bill, forbad advance towards Inverness for a decade after traffic to Fort William had begun. If the North British meant to achieve in two moves what the Glasgow & North Western had attempted in one, that intention soon wavered. Highland and North British, though at odds over the Mallaig Extension (which threatened Strome Ferry more than Oban), were in accord over the Great Glen: it should remain a no-man's land. Though briefly committed to rival promotions in 1894–5, they soon refashioned their Agreement and withdrew their respective Bills.

Where Appin and Ballachulish had the promise of a Callander & Oban branch, the Great Glen seemed indefinitely 'locked up'. Local indignation joined with outside speculation to undermine the Agreement a second time, and in 1896 the independent Invergarry & Fort Augustus Company won their Act. But powers for a Fort Augustus–Inverness extension were not achieved, and the investors' hope of selling out advantageously to Highland or North British proved mistaken. The Invergarry & Fort Augustus would remain a waif among railways. Worked at first by the Highland Company (1903), then by the North British (1907), it was closed for many months and finally purchased by the North British at little more than scrap value (1914).

The proprietors along the West Highland were all supporters or, at worst, stood neutral. (West of Fort William, opposition for the moment ceased to matter when Roshven was deleted.) It became the promoters' case that public-spirited landowners, allied with the burgh of Fort William, had instigated the scheme and persuaded the North British to assist. This highly selective version of events, though hotly disputed by the Caledonian Company and the Highland, played well before the Parliamentary committees, disguised North British empire-building and softened the speculative interest of engineer and contractor. The final layout met landlord wishes. Alterations south of Crianlarich were included in the original Bill, while deviations in Glen Spean and on the outskirts of Fort William were covered by a supplementary Act (1890), which also authorised a short extension across Fort William pier-head and a branch to the Caledonian Canal at Banavie. (With a new 'Banavie' on the Extension, the branch terminus would become 'Banavie Pier'.) Both engineering decisions and proprietors' requirements explain the substitution of a roundabout line across Rannoch Moor for a direct line via Glen Coe.

Contractors Lucas & Aird brought colonial experience to building the West Highland. Work began simultaneously at Craigendoran, Arrochar, Crianlarich, Tyndrum and Fort William. From Craigendoran to Strathtulla, a line was continuous by 1893; meanwhile the Fort William team, supplied entirely by sea, had built by Glen Spean and Loch Treig to the heights of Rannoch. A 'last spike' ceremony was held that September near Cruach. Opening was to be all-at-once, 100 miles without town or sizeable village, and completion for the late summer of 1894 was a race against time. The challenge of boggy Rannoch Moor lay not in the method of construction

(including 'floating' embankments) but in the huge volume of 'fill' required. Ballast trains were restricted until the viaducts further south were ready.

Charles Forman's 'contouring' technique, reducing heavy works, gave the West Highland its enduring character, to which the chalet-style station buildings also contributed. 'Different' within the North British system, the West Highland would remain 'different' after the Grouping, a far-flung appendage of the LNER (while LMS anonymity crept over both the ex-Highland Dingwall & Skye and the ex-Caledonian Callander & Oban). Formidable gradients and tight curves were accepted, which mattered little in the short run – though the North British soon appreciated that, whatever happened in the Great Glen, a competitive route to Inverness would demand much additional expenditure on the original line north from the Clyde. In the long term, operating limitations and an indirect route would put the West Highland at risk from twentieth-century road improvements. Along the Gare Loch, provision of crossing loops was generous, in anticipation of 'residential traffic'. North from Garelochhead, three passing places – Glen Douglas, Gortan (Gorton) and Corrour – broke the longest station-to-station sections. Glen Douglas, in the hills above Loch Long, would flit in and out of the passenger timetables. Gortan, where Strathtulla opens onto Rannoch Moor, remained least known – it has been discovered more than once by journalists in search of copy. Bleak Corrour, on the moor's northern edge, graduated to private station (for Corrour Lodge) and later became fully public.

The West Highland Company, its independence a fiction, was fully absorbed into the North British from 1908. Initiated in a climate of extravagant competition which was about to pass away, the route was completed to Mallaig a dozen years later in a new era of retrenchment, increasing regulation, rising costs and brittle labour relations. Coldly considered, the West Highland should not have been built. Hindsight aside, it seems certain that, some few years later, it would not have been built as we know it. In 1896, with government assistance at last secure, construction of the Mallaig Extension as a conventional line was put in renewed doubt when opponents seized on the impending Light Railways Act and urged a fresh look at the whole project.

North British commitment was by no means negligible, despite 'second thoughts' (see above). Coaching stock of high quality for the period was dedicated to the Glasgow–Fort William service and found favour with tourists; similar vehicles were employed between Edinburgh and Fort William. By 1902 the track had been substantially re-laid and curves eased. The 'West Highland Bogie' 4-4-0s, which performed adequately on the trains of the 1890s (typically a three-coach set plus brake-van), soon struggled as passenger loadings increased. Larger, stronger locomotives were needed across the railway industry, and the North British conformed, after a penny-pinching interlude which only postponed the inevitable. By 1914 'modern' mixed-traffic 4-4-0s (first 'Intermediates', then 'Glens') were in West Highland service.

From the beginning, summer traffic posed problems, as would intensive working of fish specials (and fish empties) when the Extension opened. Fort William's accommodation was cramped (with excursion stock sometimes stabled at Spean Bridge) until sidings were added at Banavie Junction (subsequently Mallaig Junction). Provision of additional passing places (on Lochlomondside, in Glen Falloch and above Loch Treig) was a question repeatedly shelved. Some outlay followed from operating experience. Loose rock above the narrow terrace north from Glen Douglas was buttressed and patched; snow fences and the Cruach shelter were erected; paired water-columns served

the frequently double-headed trains; and turntables at Crianlarich and Rannoch gave flexibility (not least for winter patrols and snow-ploughing). For livestock handling at Fort William (where an auction mart was among the improvements stimulated by the new railway) a looped siding, bank and pens were inserted on the town-side of the main line. But the North British would not contemplate, without a matching government commitment, further major spending on Mallaig harbour. After the Grouping, the LNER reviewed the arguments and took the same position.

The North British did not favour the 4-6-0. To reduce piloting on West Highland passenger trains, the LNER brought in K2 2-6-0s, which originated on the former Great Northern Railway. The engines transferred acquired a distinctive cab, more suited to Scottish conditions, and some of them became 'Lochs', perpetuating the North British practice of territorial naming. From the first, 0-6-0s of classic design proved reliable on goods, ballast and snow-plough duties, doing passenger work when required: as classes J36 and J37, North British examples would endure till the end of steam. Post-Grouping LNER design policy was 'horses-for-courses'. Six K4 2-6-0s were dedicated to the West Highland and appropriately named, while the V4 light 2-6-2 (an experimental class of two) was conceived with the West Highland in mind. J39 0-6-0s also appeared on goods work. Only in the 1940s, under war and post-war conditions, did the 'no-frills' mixed-traffic 4-6-0 finally appear (in the shape of Class B1). 2-6-0s still dominated the Extension, where passenger duties would gradually pass to the robust K1s, derived from the powerful but temperamental K4s.

Outer-suburban traffic between Glasgow and Garelochhead never developed as projected. A local train, three or four times daily, between Craigendoran and Arrochar & Tarbet proved ample, lasting just long enough to be 'dieselised'. Two 'push-pull' North British 4-4-2 tanks (Class M, LNER C15) served long years on the Arrochar shuttle, reinforced from the 1930s by the LNER's V1 2-6-2 tanks. On the Invergarry & Fort Augustus, diminutive North British 4-4-0 tanks (Class R) readily coped with winter passenger traffic – often a solitary composite coach; but tender-engines and 0-4-4 tanks also appeared. Under LNER ownership, C15 tanks saw out the passenger service.

Until 'Mallaig fish' became the West Highland signature, Fort William's whisky traffic (barley, coal and draff, besides the finished product) was the largest source of freight revenue. A new distillery, east of Nevis viaduct, joined the two already established; all three obtained sidings. At certain seasons sheep or cattle needed special arrangements (livestock 'wintering' was a steady business); but a daily general goods in each direction, supplemented by conditional workings between Glasgow and Crianlarich, was usually sufficient, shunting station by station. Domestic coal was a traffic partially won from the coastal steamers. Plodding up goods met plodding down goods approximately midway – and each was crossed too, and overtaken, by passenger trains. Leisure travellers included the customers of Shandon Hydropathic.

Between the wars, the British Aluminium Company's new smelter outside Fort William and the Lochaber Power Scheme, on which the plant depended, would transform this picture. Construction traffic was important – and the Power Scheme included a 1½-mile deviation at the foot of Loch Treig. Thereafter alumina north from Burntisland and aluminium south to Falkirk became West Highland staples. When oil and petrol tankers superseded drums by wagon-load, an Esso siding was contrived at the town yard, while BP was accommodated at Mallaig Junction. A roomier building behind the livestock bank replaced the original goods shed, and LNER

tractor-trailers replaced horse-and-cart. Overnight goods trains were added to the timetable, and these 'Ghosts', like the passenger 'Sleepers', became a West Highland institution. There were (though not invariably) two 'Ghosts' up and down, one devoted primarily to 'BA' traffic.

The coming of British Aluminium enlarged Lochaber's population, increasing year-round passenger business. Britain in the 1930s, despite the large minority trapped by the long Depression, experienced a foretaste of 1950s and 1960s consumerism, with purchasing power more widely spread and paid holidays more common. This was reflected in West Highland summer traffic, for which the LNER introduced open-saloon passenger vehicles, cheerfully green-and-cream. The 'Northern Belle' (ancestor of the leisure and rail-experience tour trains which operate today) offered a week's 'cruise' of the LNER's scenic districts. In a typical itinerary, the voyagers re-joined the day-coaches at Ardlui, from a Loch Lomond steamer, to continue to Mallaig and back to Fort William, where the night coaches waited. Camping coaches appeared at certain West Highland station, complemented by experimental 'apartments' in redundant station buildings on the Invergarry & Fort Augustus.

I&FA passenger business ceased in 1933. Summer sailings on the Caledonian Canal were a relic of Victorian tourism, overtaken by social change, and ended with the 1939–45 war, as did the vestigial passenger service to Banavie Pier. Wartime traffic, much larger than in 1914–18, gave the Fort Augustus line a final lease of life and tested the West Highland to capacity. Sidings at intermediate stations were lengthened. More sidings were put in at Mallaig Junction and existing sidings looped. At Faslane, on the Gare Loch, an emergency port was created. Military, naval and special-service personnel, munitions, and troops on exercise all required transport. Spean Bridge became the railhead for Commandos at Achnacarry.

On the West Highland, as on many secondary lines, post-war Austerity lingered after Nationalisation (1948). The Banavie branch closed in 1951. But by the late 1950s the summer timetable, especially on the Extension, again embraced a variety of day excursions and circular tours by train, coach and steamer. With the average holiday still weekend-to-weekend, Saturday relief services were well-patronised. A popular initiative, from 1956, was the deployment of the ex-LNER 'Coronation' observation cars. The K4s were increasingly confined to the Extension and 'Glens' became infrequent visitors; but Black 5 4-6-0s arrived in force, supplemented by Standard 5s and outnumbering the native B1s. Though 2-6-0s in general were gradually displaced, save as pilots, from passenger duty between Glasgow and Fort William, the double-headed trains of summer exhibited every possible pairing, 4-6-0-with-2-6-0, or 4-6-0-with-4-6-0.

Ominous long-term trends – changed patterns of spending, car ownership, holidays abroad and road improvements – were scarcely addressed. Hasty abandonment of steam, announced in 1955, seemed a dubious strategy; but modernisation, on the face of things, would secure the future. In fact, the switch was ill-conceived, wasteful and preliminary to very different and drastic proposals which might have eliminated every railway in the Highlands. The Wiggins-Teape Pulp and Paper Mill to be established at Corpach (Annat) explained the West Highland's Beeching reprieve, but another factor was Loch Linnhe's potential as a Cold War base. (The US Navy preferred the Holy Loch, complementing Britain's Polaris installation at Faslane.)

A range of Type 2 diesel-electrics tried their paces before 'Birmingham Sulzers' (subsequently Class 27) established themselves as 'West Highland engines' in the manner of 'Lochs' and 'Glens'.

The Annat plant generated traffic in timber and chemicals besides pulp and paper and Oban trains began to run via Helensburgh. Craigendoran (WH), Rhu and Shandon disappeared; Helensburgh Upper and Roy Bridge lost their passing loops. The net result was a busy line, with successive crossings instead of one or two lonely 'meets'; but these gains were others' loss, with the Callander & Oban route half-destroyed. Moreover, the Arrochar locals had gone and the Extension's future was doubtful. Ensuing decades turned nervous. A Class 27 on a traditional rake had been reassuring: a Class 37 heading three Mark 2 coaches (one with an improvised and unloved buffet-counter) was obviously a stop-gap...pending what? The B.A. smelter, small-scale by modern standards, had aged. Whispers that pulp and paper production was unviable became, in the event, amply justified. Fish traffic had already far declined, with coal, oil and general freight set to follow. When Anglo-Scottish over-night trains were concentrated at London Euston, the West Highland 'Sleeper' continued, but its long-term prospects seemed bleak.

The last twenty-five years – on balance a positive story? – are largely covered by photographs. Radio-signalling has proved itself; Sprinter DMUs, despite their drawbacks, give a winter timetable more generous than in steam days; the 'Sleeper' survives; Alcan's modernised smelter remains in business; other freight, including timber, has been retained or regained, though erratically; leisure traffic – for walking, skiing, mountain-biking and 'West Highland steam' – has grown; mechanised maintenance has become the rule. It bears remembering that the LNER put a 'Karrier' road-railer on the West Highland some eighty years ago.

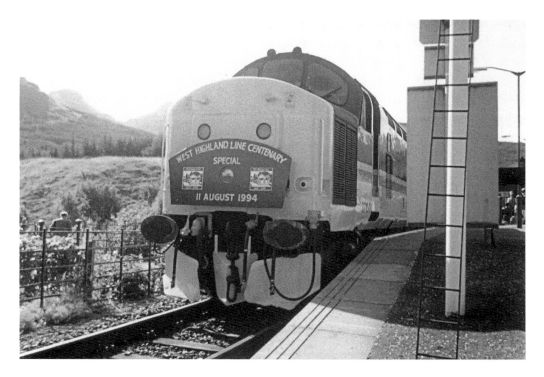

The 'Centenary Special' (1994) stands at Crianlarich. Guests joined the train at several stations on the way north. (*Christine McGregor*)

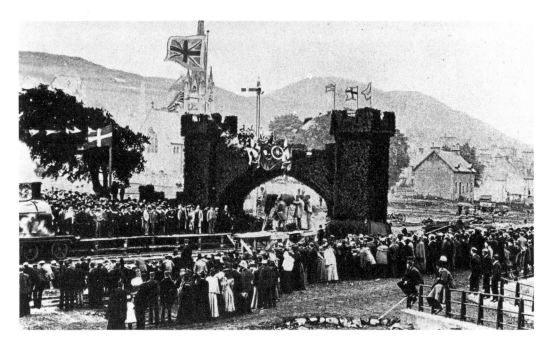

Celebrations

Traffic began on 7 August 1894. The official opening, at Fort William, came four days later. A sturdy arch of heather, with pipers on the 'battlements', straddled the main line. A padlocked gate was formally unfastened, and the special train steamed through the arch.

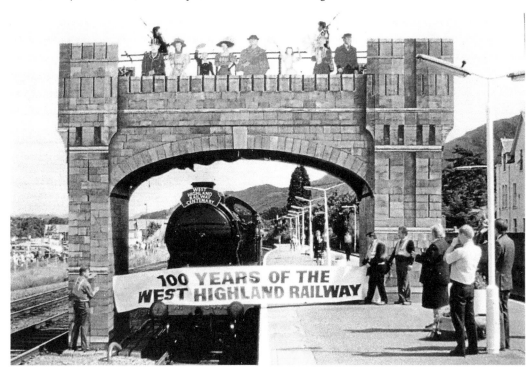

11 August 1994 saw this ceremony re-enacted at today's Fort William station. (*Stevenson*)

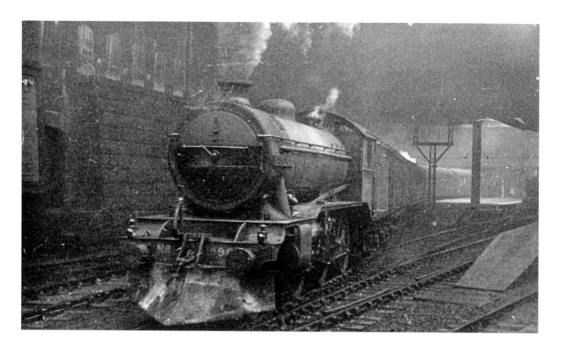

Glasgow to Fort William

Not since the 1840s has Glasgow Queen Street been called 'an almost fairy palace' (a description of the original gas-lit station). Opening out the tunnel mouth became imperative, and the roof (dating from the 1870s) has some dignity. But smoke and soot had long prevailed when, in October 1947, LNER K4 2-6-0 1996 *Lord of the Isles* heads the evening train to Mallaig. Note the buffer-beam snow plough, as also seen on page 13. (*H. C. Casserley*)

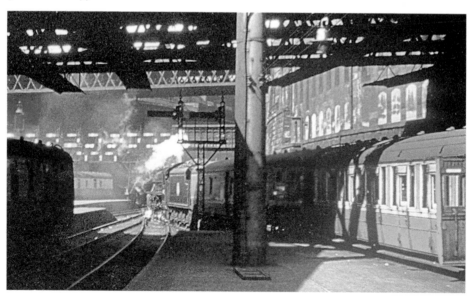

A decade later, 4-6-0s were common on the West Highland, as was British Railways coaching stock. In April 1957 an ex-LMS Black 5 heads a Fort William train. Carmine-and-cream, already giving way to maroon, was an unpleasing livery for older vehicles. (*Chamney*)

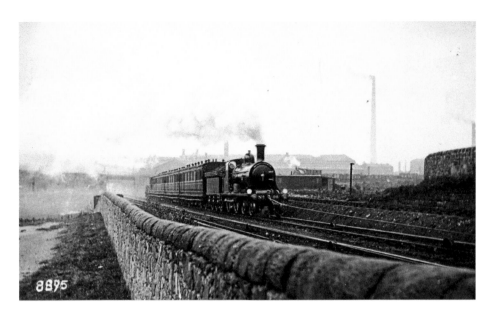

A West Highland Bogie (North British Railway Class N 696) takes a West Highland train up Cowlairs Incline, with cable assistance. Despite the archaic array of ventilator bonnets, these compartment-and-saloon coaches set a high standard at the time. (*Hennigan/AEL*)

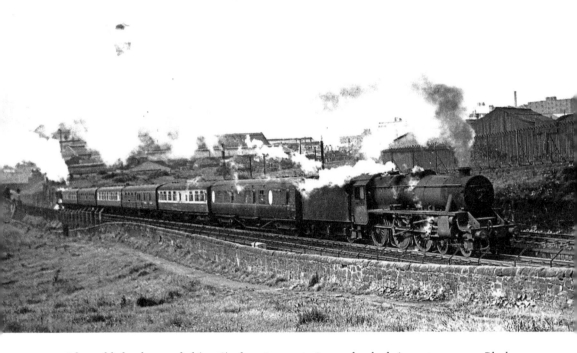

After cable-haulage ended (1908), almost every train was banked. August 1957 sees Black 5 44973 on the mid-morning summer service to Mallaig, with a V1 2-6-2 tank working hard at the rear.

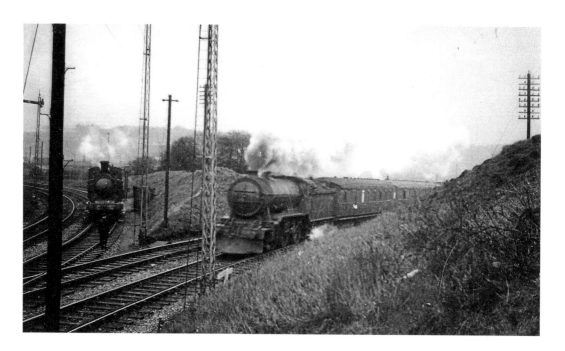

In April 1949 an ex-LNER K2 2-6-0 approaches Cowlairs North Junction, taking the Helensburgh line with the evening Glasgow–Mallaig. Like the K4 on page 11, it carries a buffer-beam snow plough. An ex-North British tank stands on the East Junction–North Junction spur, whereby West Highland trains originating elsewhere can avoid reversal.

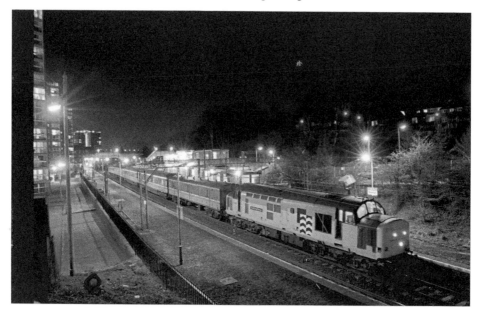

Before the DMU era, the Sleeper to and from Fort William was, strictly speaking, the West Highland London portion, uniting with the early Glasgow–Mallaig and the afternoon Mallaig–Glasgow. It has survived precariously as an independent train, here seen at Dalmuir. Dalmuir has become the West Highland's interchange with the Strathclyde rail network. (*Crawford*)

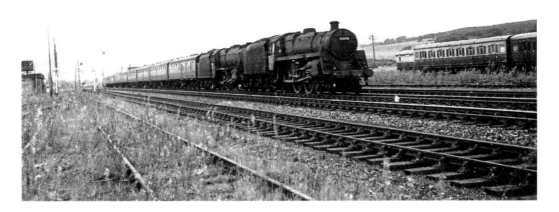

Just east of Craigendoran Junction in September 1955 is an up West Highland service with two 4-6-0s (BR Standard 5 73078 and Black 5 44995) in charge. (*H. C. Casserley*)

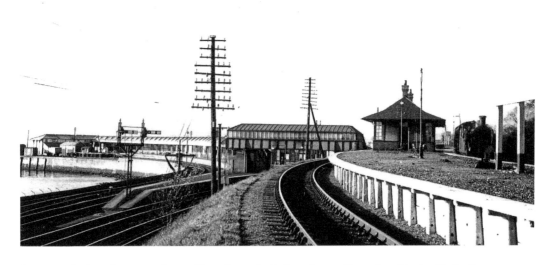

In 1955 Craigendoran station still embraced Craigendoran Pier, the North Clyde line to Helensburgh and, at a higher level, the West Highland. An Arrochar local has arrived at the West Highland 'island'. (*Stevenson*)

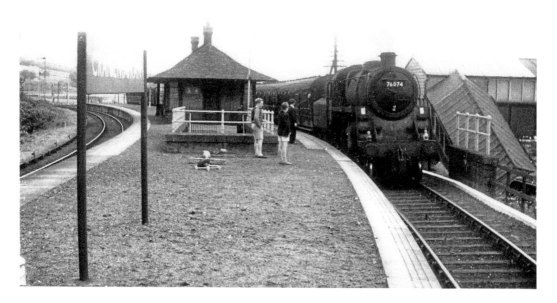

In June 1960 BR Class 4 2-6-0 76074 pauses at Craigendoran with the Saturday afternoon Glasgow–Crianlarich. This summer service connected with sailings on Loch Long and Loch Lomond. (*R. M. Casserley*)

In 1987 the West Highland platform and passing loop are long gone as two EE Class 37s on alumina empties from Fort William have a clear road through the Junction. Electrification around Glasgow was pioneered on the North Clyde line. (*Crawford*)

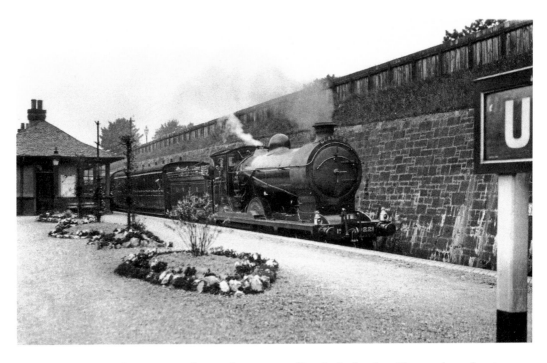

In early LNER livery, ex-North British D34 9221 *Glen Orchy* heads a Glasgow-bound train at 'Helensburgh Upper'. The North British had preferred 'Upper Helensburgh', while the town's terminal station became, and remained, 'Helensburgh Central'. (*Lens*)

The West Highland promoters counted on residential traffic along the Gare Loch; the covered ramp is a reminder of expectations unfulfilled. (*Johnstone*)

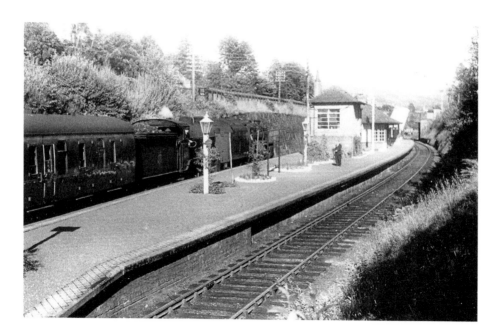

A 4-6-0 leading a 2-6-0 was a frequent pairing in the 1950s. North British practice endured, with the pilot coupled 'inside' and token (tablet) exchange the responsibility of the pilot fireman. On a July evening in 1957, Standard 5 73077 and K2 61791 *Loch Laggan* bring the principal Mallaig–Glasgow, with through coaches for Edinburgh, into Helensburgh Upper. During the Second World War a raised signal box was installed, giving sight of the extended loop (*R. M. Casserley*)

Today, the platform has a single face and Sprinter DMUs form the ordinary trains. From Helensburgh northwards, the West Highland is radio-signalled; the modern box at Banavie controls the whole route. (*McNab*)

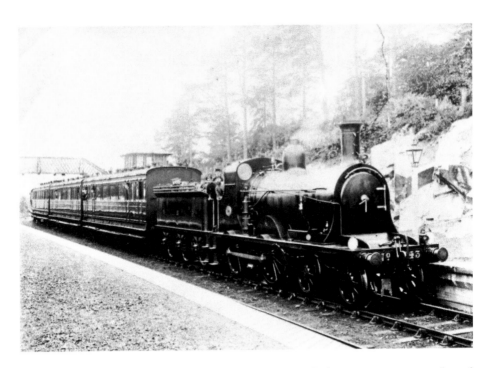

Rhu ('Row' in North British nomenclature) was a side-platform station in an awkward cutting; a taller signal box was required from the outset. West Highland Bogie 343 on an up train of West Highland stock typifies the line's earliest years. (*Hennigan/JT*)

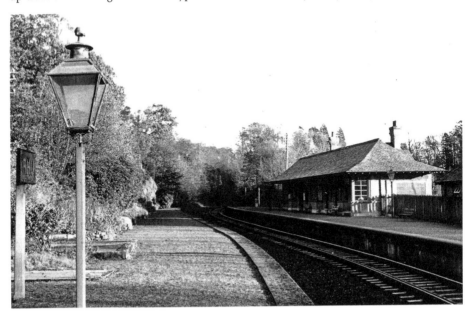

The loop was removed in the 1920s, restored during the Second World War then removed again. Closure in the 1960s was followed by a brief resurrection. The remains are today easily missed. (*Stevenson*)

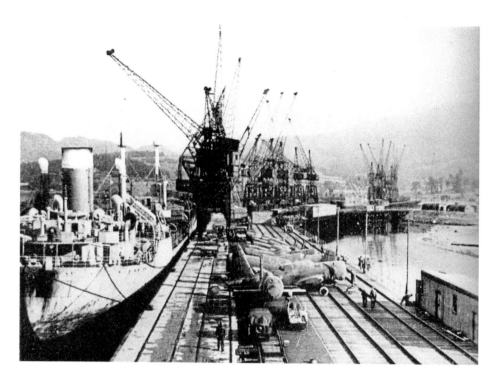

In 1942, Faslane on the Gare Loch became a wartime emergency harbour, with rail access from the West Highland. Locomotives of several types worked between Craigendoran, where additional sidings were installed (see page 14), and the 'secret port'. Faslane, subsequently a ship-breaking yard, is now a controversial nuclear submarine base.

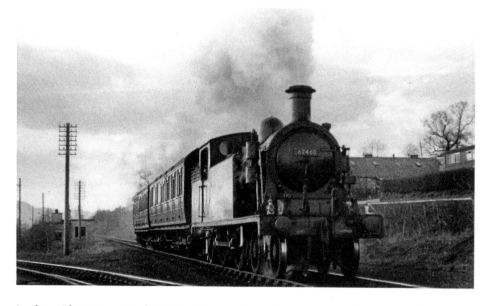

In the mid-1950s ex-North British C15 4-4-2T 67460, on an Arrochar–Craigendoran push-pull, passes Faslane Junction. The Junction and its wooden platform are now all but obliterated. During construction of the Loch Sloy hydro-electric scheme, workmen's trains used this temporary halt: the labour force included prisoners-of-war. (*C. Lawson-Kerr*)

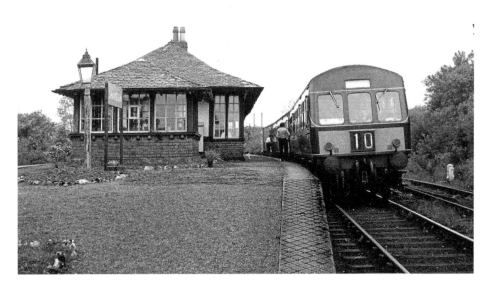

A first-generation DMU is caught at Shandon in May 1959. These diesel sets had a brief innings on Arrochar locals and summer services to Ardlui (Loch Lomond). (*Stevenson*)

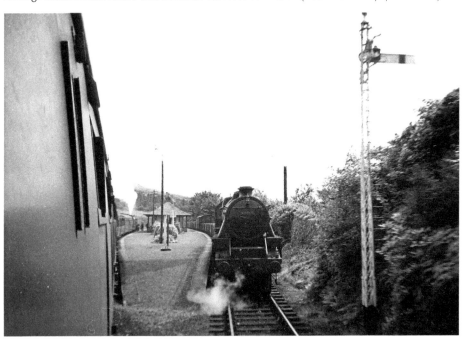

At Shandon in August 1960, Black 5 44968 on a down goods crosses the morning Mallaig–Glasgow. Shandon (now vanished) exemplified the West Highland's intermediate stations onwards to Bridge of Orchy – an island platform accessed by subway; chalet-style building (clad in imported Swiss shingles); and dwarf signal cabin. Tablet equipment for single-line operation was placed in the station offices (which at first the railway inspectorate questioned). (*Currie*)

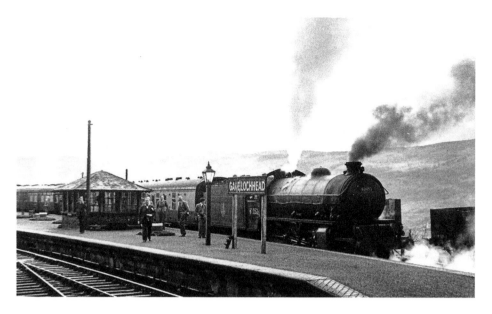

In April 1952, K1 2-6-0 62052 on the evening Glasgow–Mallaig pauses at Garelochead (the camera-ready party are expecting an up goods). (*H. C. Casserley*)

The subway entry in October 2012 is captured by Alan Johnstone. Because the line follows the hillside, communities along the Gare Loch have always found their stations less than convenient, even with an official 'Welcome'. Fort William trains were first intended to coordinate with 'outer suburbans', running between Glasgow and Garelochhead (where a turntable was provided).

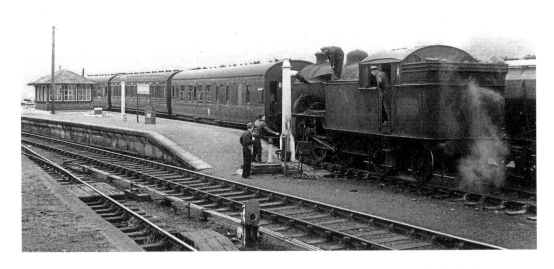

A local shuttle between Craigendoran and Arrochar & Tarbet was substituted for the 'outer suburbans', connecting with Helensburgh Central trains. Besides the 'push-pull' C15s, V1 2-6-2Ts were employed. At Garelochhead in June 1961, 67626, on the afternoon Craigendoran–Arrochar, takes water. The half-hidden vehicle is an ex-LNER alumina hopper. (*Stevenson*)

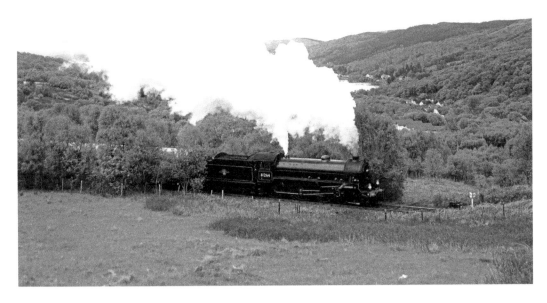

Preserved B1 61264 climbs away from Garelochhead with a down steam special. Like the K1s, this class was expanded after Nationalisation. (*Crawford*)

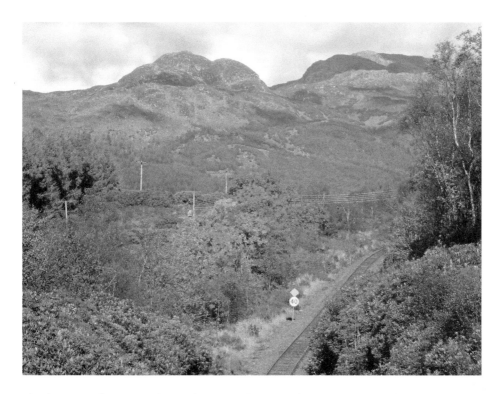

The line cuts the narrow base of Roseneath peninsula to emerge at Whistlefield, above Portincaple, on Loch Long. The Gare Loch, now left behind, has Lowland affinities, but the mountains ahead are incontrovertibly Highland. (*Johnstone*)

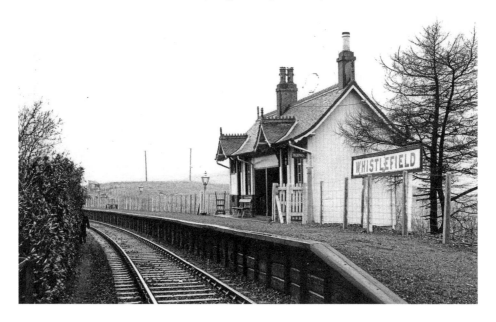

Facilities for Lochlongside were something of an afterthought, under pressure from the landowner. Whistlefield (1896), sited on a testing gradient, had its own character. Scarcely a trace remains. (*Stevenson*)

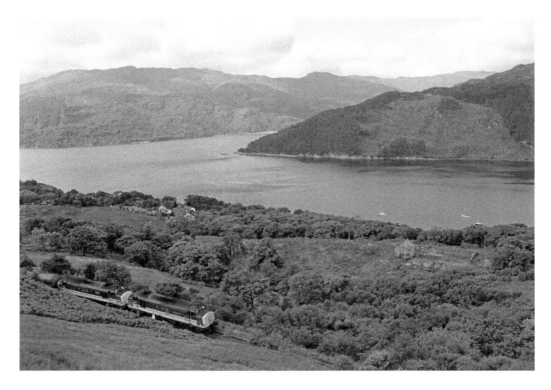

In 1991, with Loch Long and Loch Goil in the background, two Class 37s with alumina tankers for the smelter at Fort William climb past Whistlefield. (*Crawford*)

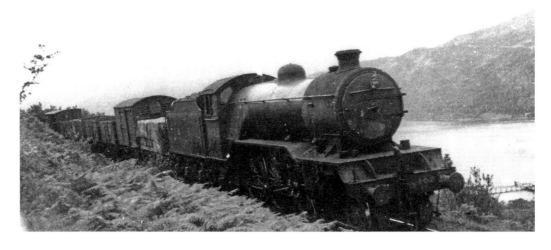

A few miles beyond, Loch Long and Finnart pier are far below, as V4 2-6-2 3402 (later 1701) heads a down wartime goods in 1942. (*Stevenson*)

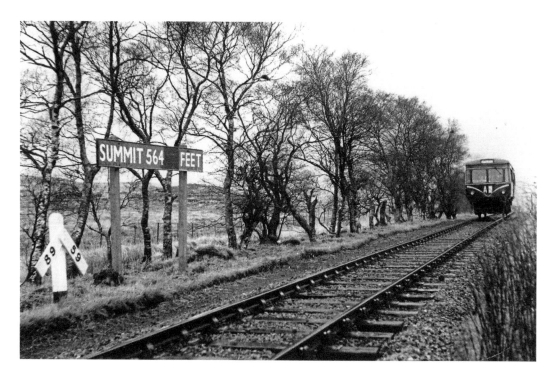

A Park Royal rail-bus provides the local service to Arrochar & Tarbet, topping Glen Douglas summit in May 1961. The Craigendoran–Arrochar shuttle would last three years more. (*Stevenson*)

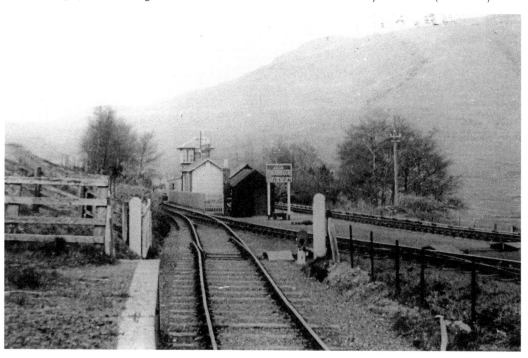

At Glen Douglas passing place (just north of the summit) a siding and loading bank, for which local farmers petitioned, were early additions. (*Stevenson*)

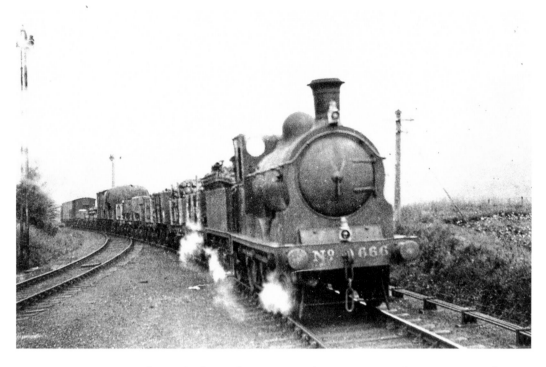

In August 1920, North British Class C (later LNER J36) 0-6-0 666 *Marne* brings an up goods into Glen Douglas. After service in France, twenty-five engines of this class received First World War-related names. (*Lynn*)

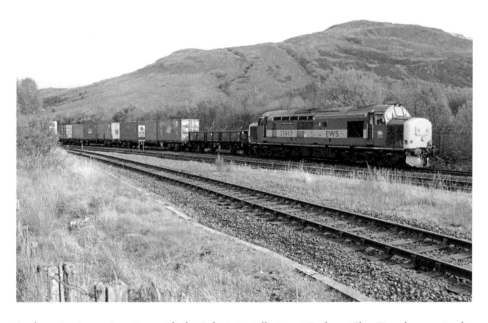

In the 1960s, in conjunction with the Polaris installation at Faslane, Glen Douglas acquired a bleak and forbidding Ministry of Defence depot, now softened by time and nature. A Class 37-hauled MoD train departs in October 2006. (*Crawford*)

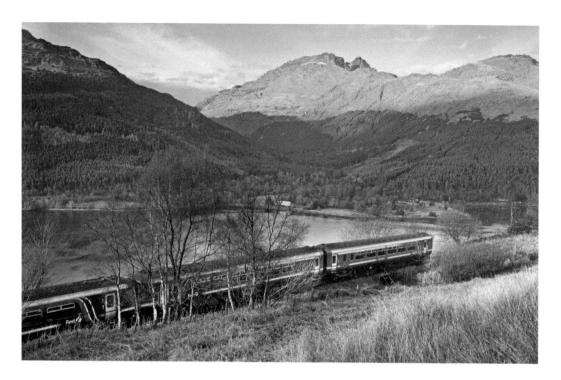

With Loch Long again below and Ben Arthur ('The Cobbler') in sight, a down Sprinter descends towards Arrochar in March 2001. The Loch Fyne Light Railway, authorised but never built, would have followed Glen Croe, which opens on the opposite shore. (*McNab*)

In an early photograph, looking back to The Cobbler from the passage between Loch Long and Loch Lomond, the scars of construction near Arrochar & Tarbet station are readily visible.

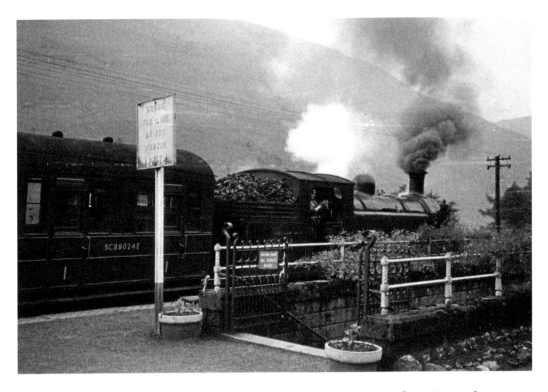

An ageing 4-4-2T waits at Arrochar & Tarbet in 1959. The engine faces Craigendoran, having propelled its two coaches on the down trip (See also page 19). The V1 2-6-2Ts ran round conventionally at each journey's end. (*Stone*)

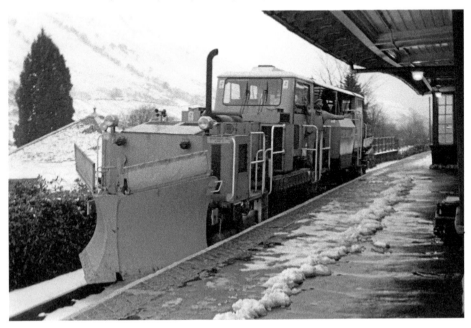

A modern self-propelled snow plough stands near the same spot in 1989. The station building has since been demolished. (*Crawford*)

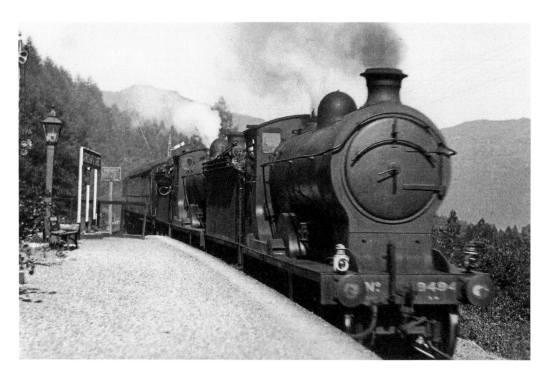

Two D34s head an up passenger train into Arrochar & Tarbet in LNER days, as the fireman on the second engine prepares to exchange tokens. The leading engine is 9494 *Glen Loy*. Most semaphores on the West Highland remained 'lower quadrant' into the 1950s. (*Lynn*)

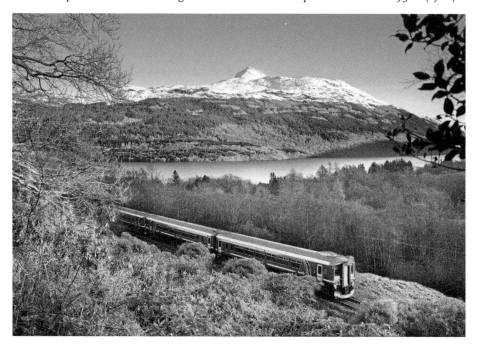

With Ben Lomond prominent across Loch Lomond, an up Sprinter approaches in January 2007. (*McNab*)

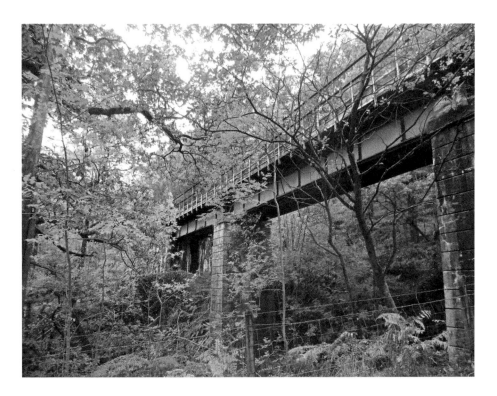

In recent decades, both natural growth and commercial planting have increased tree-cover along the route, to the detriment of traditional views. Inveruglas viaduct, on Lochlomondside, is an accessible example of the masonry-and-girder structures which characterise the West Highland. In October 2012 the setting was decidedly leafy. (*Johnstone*)

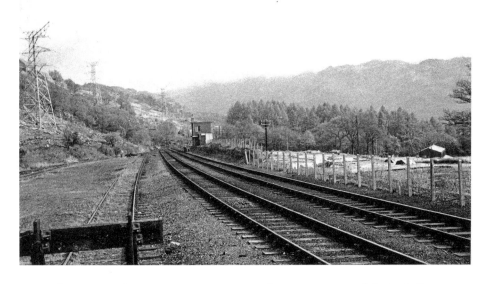

Inveruglas passing place came into use in 1945, aiding construction of the Loch Sloy power scheme. It split the section Arrochar & Tarbet–Ardlui and lasted into the 1950s (crossing passenger trains was not encouraged).

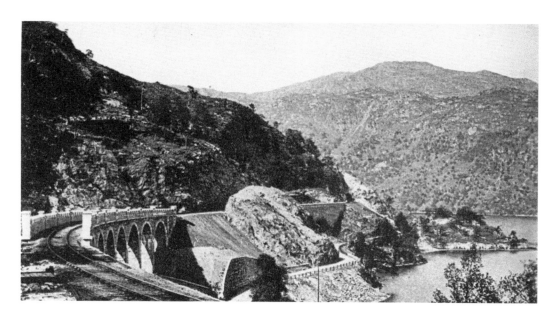

As initially surveyed, the West Highland would have followed the edge of Loch Lomond, with a causeway across Inveruglas bay. The landowner disliked stark girders and wanted a less obtrusive line – hence the handsome arched viaduct and tunnel at Craigenarden, seen in an early photograph.

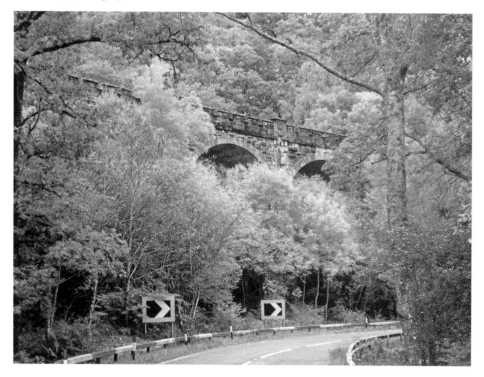

The viaduct is today weathered, mossy and obscured by trees. The short Craigenarden bore was at first the West Highland's only tunnel – a tribute to the 'contouring' technique of engineer Charles Forman. (*Johnstone*)

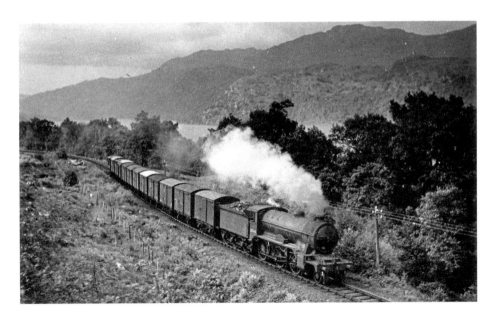

K2 61764 *Loch Arkaig* takes an up 'fish' along the northern reaches of Loch Lomond in the mid-1950s. By this time the K2s performed less regularly on the West Highland proper, save as pilots; they dwindled more slowly on the Mallaig Extension. (*C. Lawson-Kerr*)

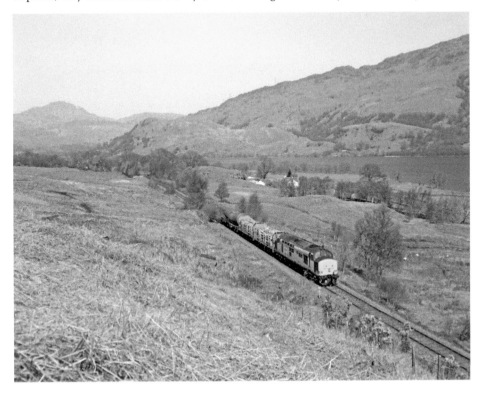

South from Ardlui, a 37 begins the relatively undemanding run along Loch Lomond with an up freight in 1991. In the distance is Glen Falloch, where down trains begin to climb again in earnest. (*Crawford*)

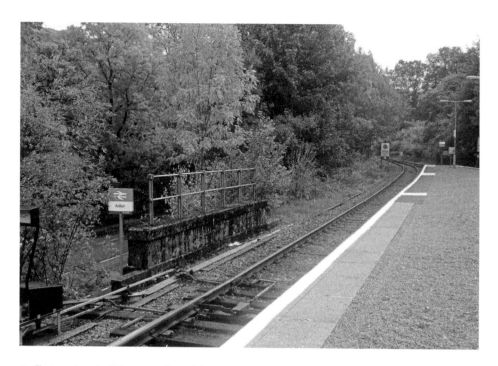

Ardlui station building, weakened by subsidence, was an early casualty, but the subway entry is now boldly signposted. (*Johnstone*)

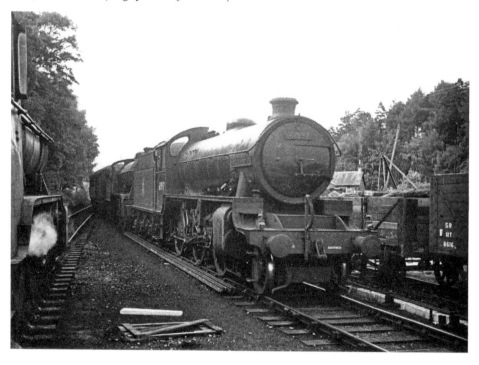

Class K1/1 61997 *MacCailin Mor*, a three-cylinder K4 rebuilt as the two-cylinder K1 prototype, leads a K2 into Ardlui on an up train of the 1950s. The true K4s generally worked alone, though this was not an invariable rule.

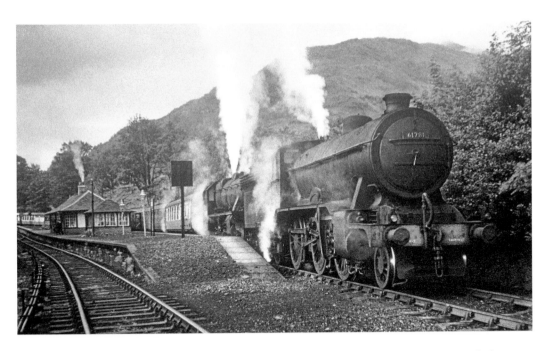

K2 61781 *Loch Morar* and a Black 5 head a down passenger at Ardlui in June 1958, with the 2-6-0 coupled ahead. Perhaps assistance up Glen Falloch was expedient? A pilot would be found 'inside', working the entire journey. (*Chamney*)

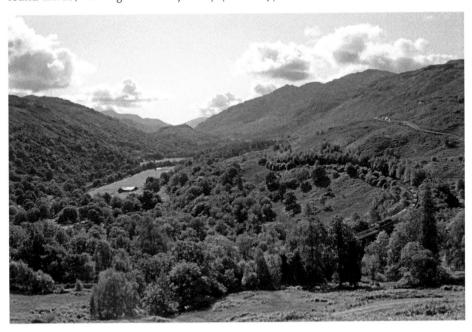

With Inverarnan, Cnap Mor and distant Ben Lomond in the background, a Class 37 crosses Glen Falloch (Dubh Eas) viaduct on a down freight in 1991. The site of Glen Falloch Platform, which briefly served the Loch Sloy works, is almost untraceable. However, the might-have-been Glasgow & North Western Railway can still be imagined, following Loch Lomond's eastern shore and the eastern wall of the Glen. (*Crawford*)

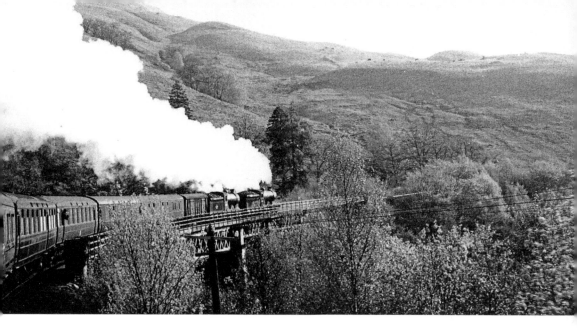

Two Glens take a regular down passenger over Glen Falloch viaduct in May 1959; the workings arranged at this time were a swansong for their class. (*Stevenson*)

A six-car Sprinter rounds the viaduct, highest on the West Highland and best appreciated from the valley floor or from a vantage point above the Dubh Eas burn. Selective felling has now reduced the 'tunnel of trees' at this and other locations. (*Crawford*)

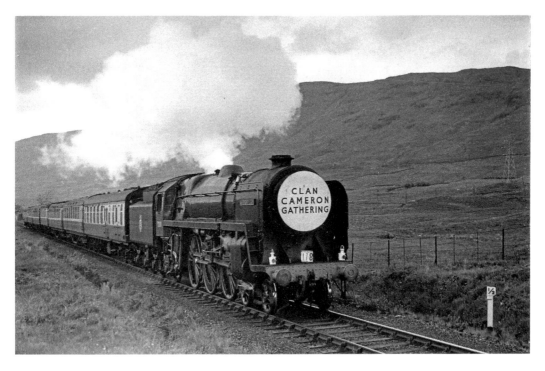

BR Standard 6 72001 *Clan Cameron* made a return run to Fort William, on scheduled trains, before heading a special to Spean Bridge for an event at Achnacarry, the seat of Cameron of Lochiel, in June 1956. The special has passed 'the fireman's rest' – a respite, northbound, from the shovel. The line dips into Crianlarich, having crossed Scotland's main watershed, which here separates the catchments of Clyde and Tay. (*Stevenson*)

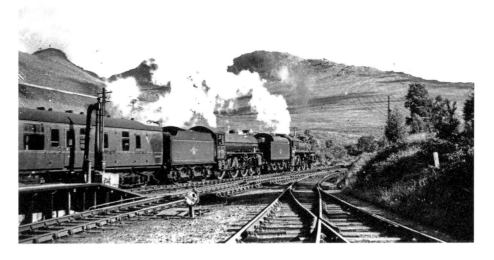

In June 1960, Standard 5 73105 and BI 61355 pull out of Crianlarich with an up service. Only one water column is visible; but Crianlarich could replenish four engines simultaneously when doubled-headed trains met. (*Casserley*)

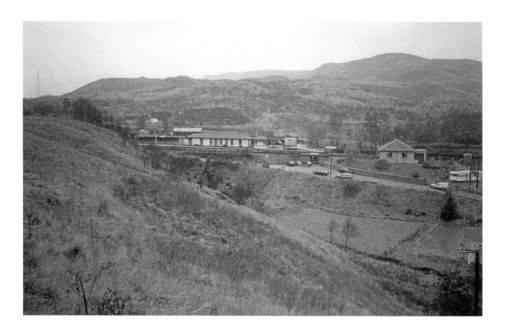

Seen from the east at Crianlarich in 1989 is the platform 'dining room' (long since a more modest café). The signal box, in cut-down North British style, looks out on Crianlarich Upper Junction. The dining room once provided speedy meals; food baskets could be ordered by telegraph (restaurant cars were a LNER innovation). A well-defined path accesses the long-distance West Highland Way. (*Crawford*)

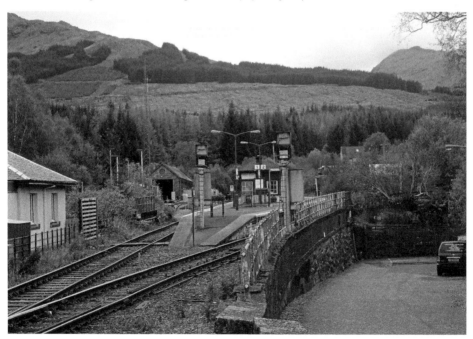

In October 2012 the signal box still stands, out of use, hiding the platform café and today's modest station building. At the modern signals, down trains have remote 'request of route' – to Fort William or to Oban. (*Johnstone*)

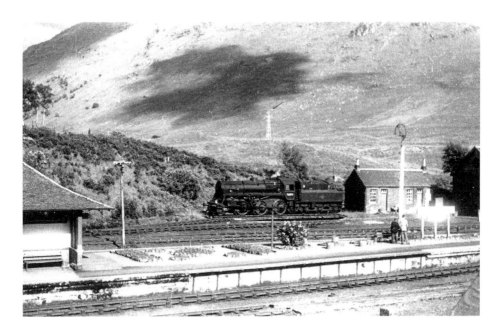

On a Saturday-evening return working to Glasgow in June 1960 (See also page 15), Standard 4 2-6-0 76074 is serviced at Crianlarich. A fire later destroyed the chalet building. When the West Highland opened, a ballast engine was assigned to Crianlarich. After experience of the line's first winter (1894/5), turntable and shed were added. (*R. M. Casserley*)

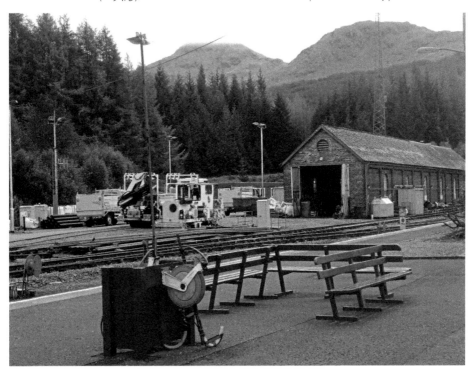

The turntable has gone but the shed, now an engineers' depot, is externally little altered. (*Johnstone*)

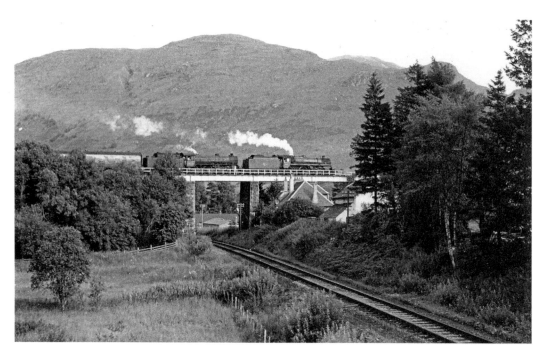

Above: On the West Highland viaduct over the Callander & Oban line, Standard 5 73007 and B1 61140 bring a southbound passenger into Crianlarich (cf. page 36), in August 1959. 1966 saw the surviving portion of the C&O 'attached' to the West Highland ('reduced to a branch' will not do; the old Oban route was senior). (*Stevenson*)

Right: Oban and West Highland trains remained distinct, until Sprinters replaced locomotive-hauled sets at the end of the 1980s. Three combined services each way is now the winter ration, dividing or uniting at Crianlarich. Ewan Crawford captures a 'splitting Sprinter'. Summer traffic demands more complicated, more lavish arrangements.

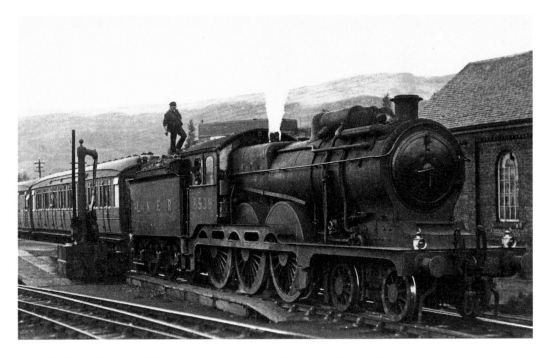

Ex-Great Eastern LNER B12 8539, on the afternoon Mallaig–Glasgow, takes water at Crianlarich in September 1938. Though the B12s transferred to Scotland after the Grouping were best known on the former Great North of Scotland system, they also ventured to Fort William. (*Stevenson*)

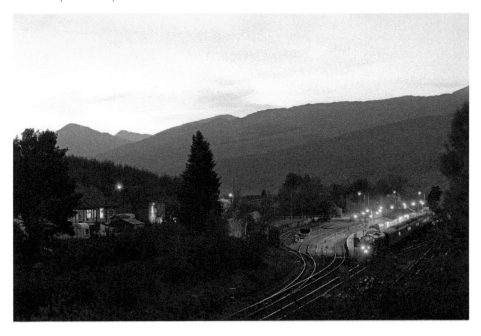

The up Sleeper calls at Crianlarich in 1995. As a train in its own right (see also page 13) it had advantages – earlier arrival into Fort William, later departure for London – but remained 'at risk'. (*Crawford*)

A freight from Fort William approaches the Upper Junction in 1990. The spur (foreground) to the Callander & Oban, controversial and long under-used, became the salvation of Oban services, which for nearly forty years post-Beeching have run via Craigendoran. (*Crawford*)

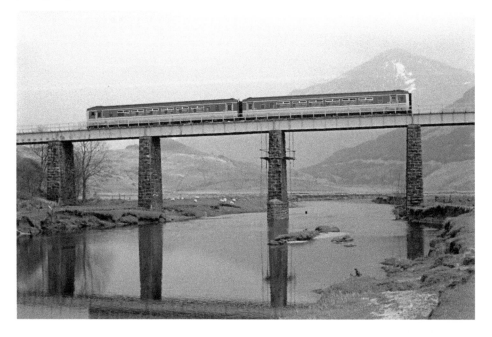

Once across Fillan Water, the gradient resumes. Behind the Sprinter on Fillan viaduct, Ben More looms above Glen Dochart. (*Crawford*)

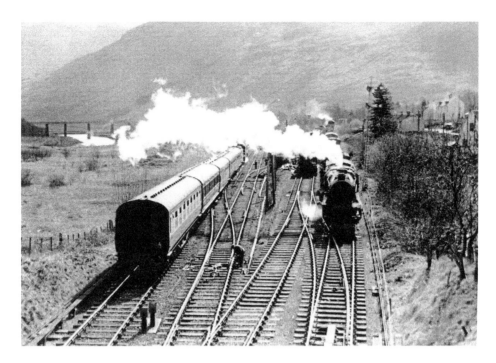

An up Callander & Oban train of the 1950s passes the Lower (or Crianlarich West) Junction when the spur seems unusually busy. Dating from 1897, this layout was over-elaborate. The Caledonian Company, working the Callander & Oban, made exacting demands. Fillan viaduct appears in the background. (*Stevenson*)

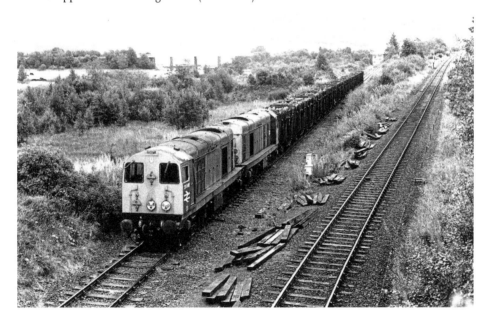

In April 1978 two Class 20s bring the daily timber train to the Lower Junction. Having loaded at the abandoned Callander & Oban station, it would reverse up the spur and reverse again to face Fort William, there reversing a third time to reach Corpach (Annat) pulp and paper mill. Fillan viaduct appears again.

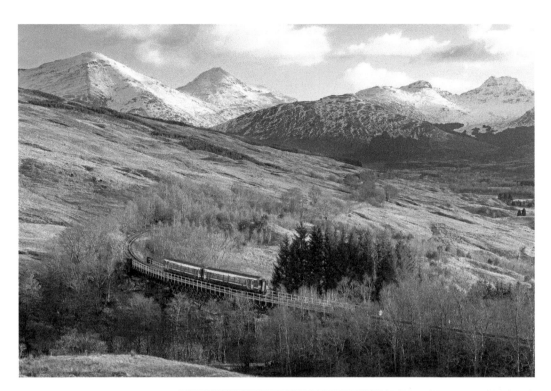

Above: Ascending Strathfillan, a Sprinter crosses Auchtertyre viaduct in January 2012. Ben More, Stobinean and their companion-mountains are lightly snow-clad. (*McNab*)

Right: Beyond Auchtertyre, restored K4 61994 *The Great Marquess* approaches Tyndrum in September 2009. Across the valley, the Callander & Oban parallels the West Highland at a lower level. (*McNab*)

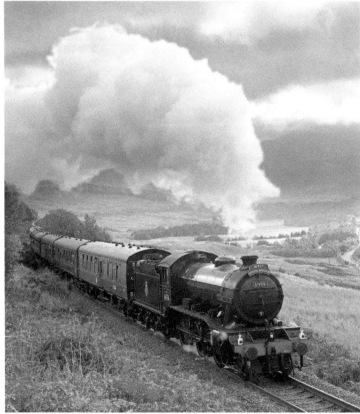

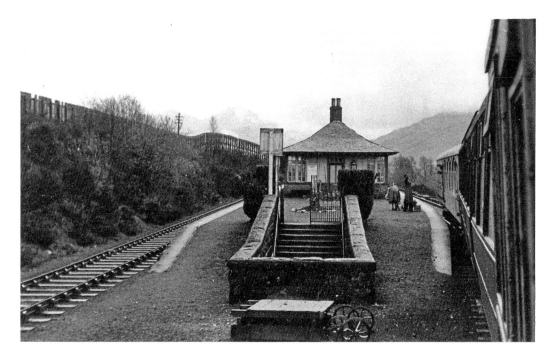

A down passenger leaves Tyndrum Upper in April 1952. Typical of the season, patchy snow remains on the mountains. The old snow fence above the station is still in fair repair. (*H. C. Casserley*)

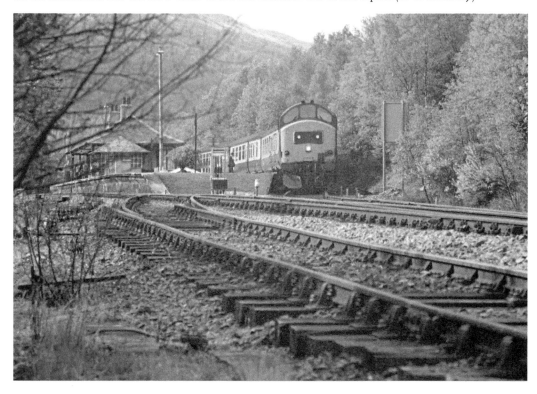

A Class 37 heads an up passenger train of BR Mark 2 stock, typical of the 1980s. (*Crawford*)

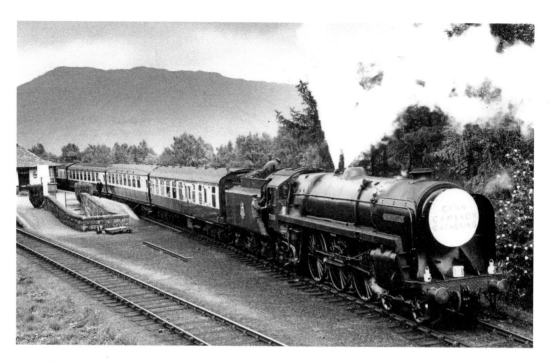

Clan Cameron stands at Tyndrum Upper in June 1956, with steam to spare for the final stint to County March summit (see also page 36). (*Stevenson*)

At the same spot in 1991 two Class 37-hauled freights exchange enginemen. Radio-signalling procedure has turned 'Tyndrum Upper' into 'Upper Tyndrum' while Callander & Oban 'Tyndrum Lower' retains its old designation. (*Crawford*)

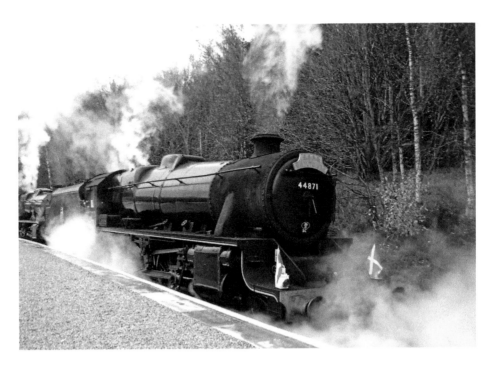

Restored steam is well-established on the Mallaig Extension. At the end of the 2012 season, two Black 5s worked south on a Scottish Railway Preservation Society return excursion, pausing at Upper Tyndrum. Christine McGregor records 44871, with Saltires decorating its lamp-brackets.

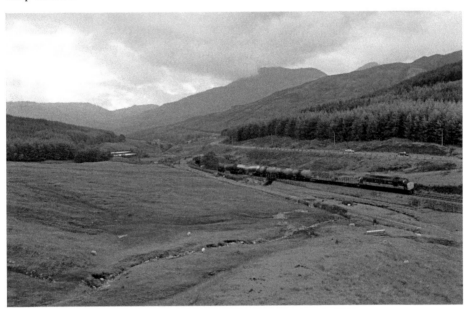

Beyond Tyndrum, a down freight of the 1990s completes the ascent which (briefly broken through Crianlarich) had begun at Ardlui. Here the old Parliamentary road forms part of the West Highland Way. Callander & Oban and West Highland have diverged, the former turning west into Glen Lochay. (*Crawford*)

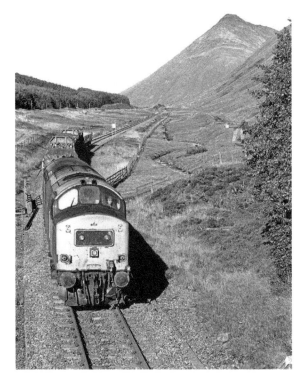

Right: An up Speedlink descends briskly from County March summit in October 1989, with the cone of Ben Dorain in the distance. (*Noble*)

Below: The West Highland today sees a range of visiting locomotives; a down special with Class 50s front and rear, is about to breast the summit. (*Carmichael*)

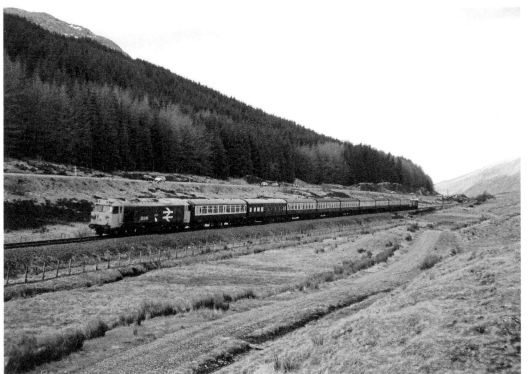

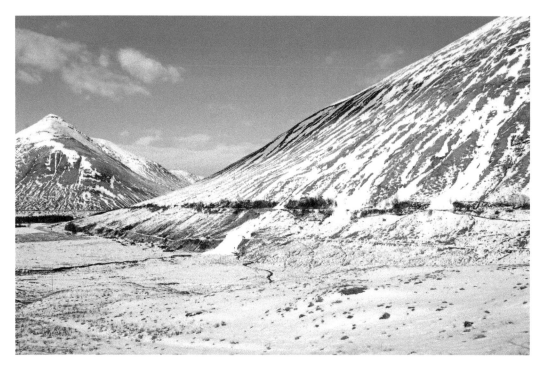

The West Highland has re-crossed the watershed and descends to Auch, where the streams drain west by Glen Orchy and Loch Awe to Loch Etive. Beneath wintry Ben Dorain, the railway emerges from the hidden Horseshoe Bend. In avalanche conditions, late snow has recently blocked the nearer track. (*Crawford*)

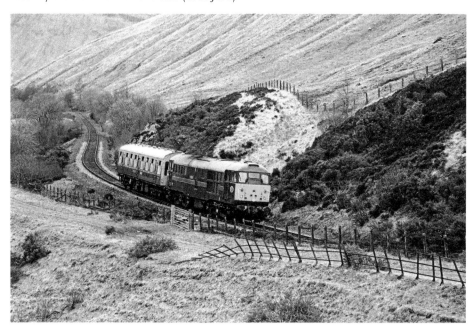

At the same location, a restored Class 31 with an inspection saloon climbs to County March from the north. (*Lyons*)

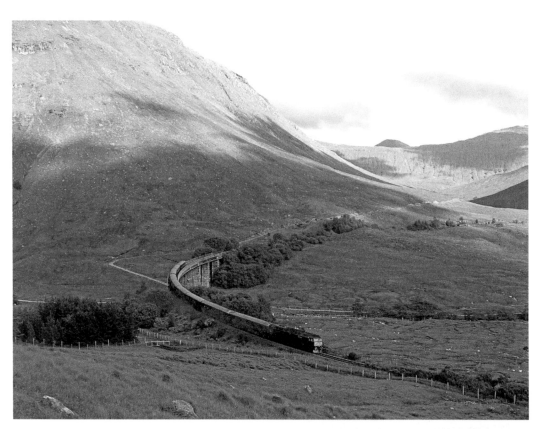

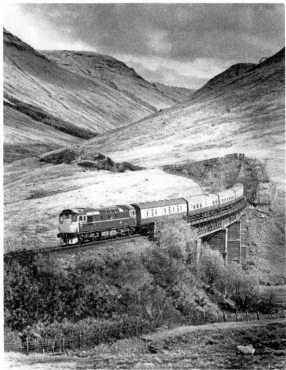

Above: Northbound on the falling gradient, a Class 47 traces the Horseshoe in July 2006 with the Royal Scotsman luxury tour train. (*Crawford*)

Right: BRCW Type 2 D5938 (later Class 27) takes the morning Mallaig–Glasgow over the lesser Horseshoe viaduct in May 1972. A three-coach set was standard (winter timetable) in early diesel days and returned as the evening Glasgow–Mallaig; a van and buffet-restaurant were added, then subtracted, at Fort William. (*Noble*)

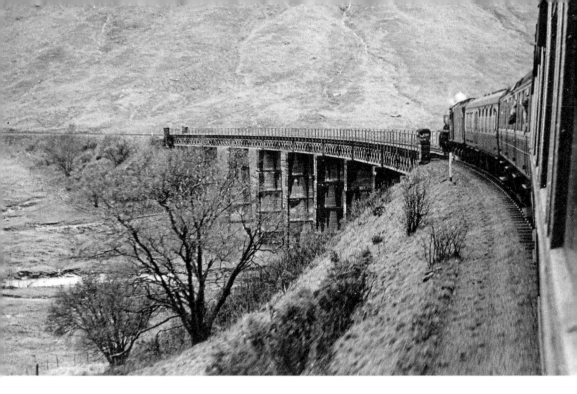

K1 60252, heading the evening Glasgow–Mallaig in April 1952 (see page 21), nears the larger (eight-span) Horseshoe viaduct. (*R. M. Casserley*)

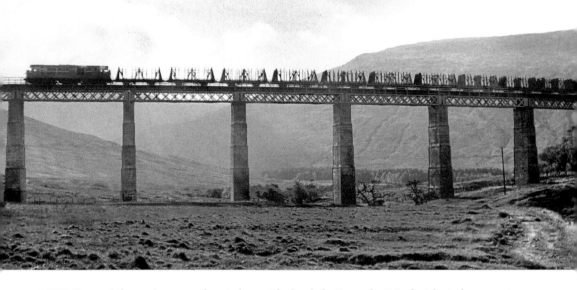

A NBL Type 2 (Class 29) crosses the viaduct with the daily Corpach–Crianlarich timber empties in the late 1960s. (*Chamney*)

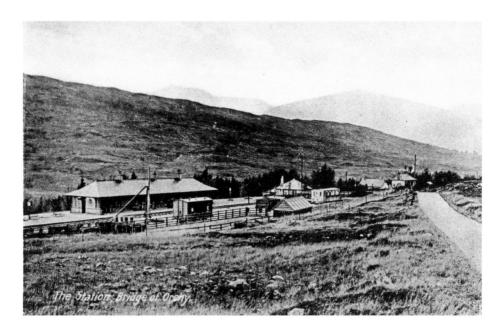

In an early photograph, the old road, now the West Highland Way, descends to the level crossing at Bridge of Orchy. (*Alsop*)

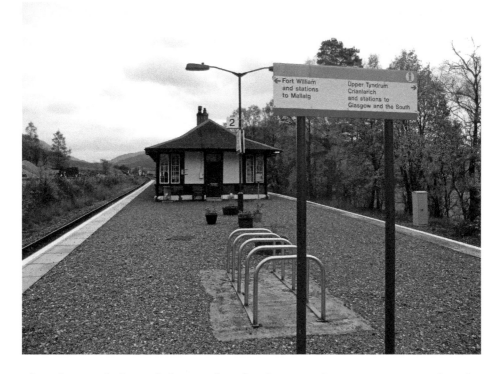

Alan Johnstone looks south from Bridge of Orchy in October 2012. Wigwam and similar accommodation for walkers has multiplied, and the station building is a bunk-house. Basic information (plus a cycle rack) awaits the rail traveller. As at several other crossing stations, 'right-hand' running is the radio-signalling rule (determined by the layout of sidings).

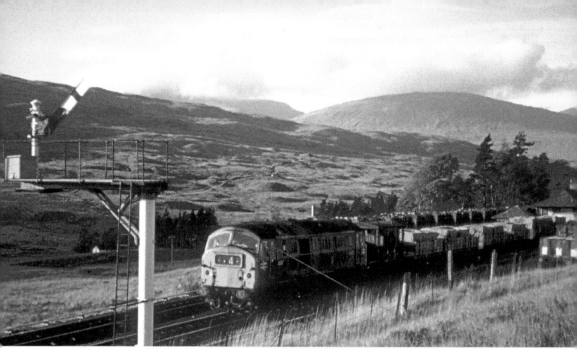

Up 'pulp-and-paper ', with a NBL Type 2 in charge, meets down 'timber' at Bridge of Orchy in September 1968. The NBLs proved unreliable – some were re-engined, to little avail; with their demise, the BRCW Sulzers became firmly established. (*Chamney*)

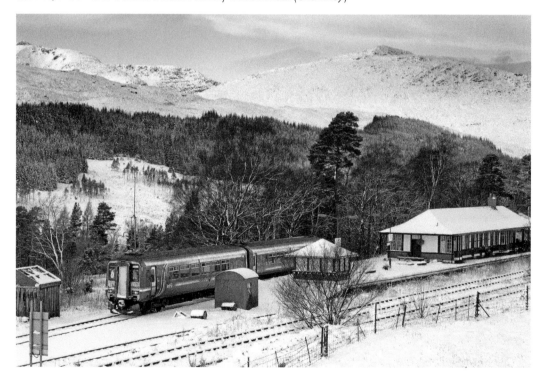

In a lonelier but very 'Christmas card' photograph (December 2009), a Glasgow-bound Sprinter departs. (*McNab*)

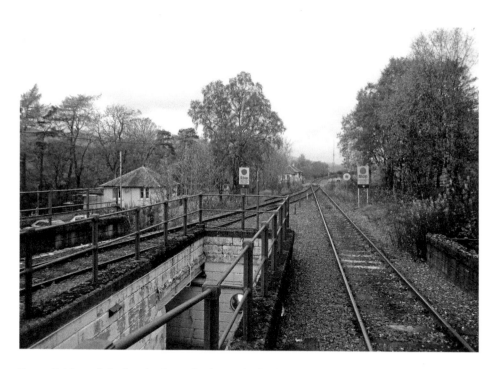

From Bridge of Orchy the line climbs in both directions: Alan Johnstone looks north. (*Johnstone*)

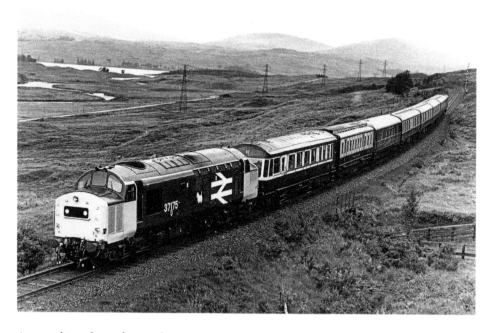

Approaching from the north, 37-175 passes Loch Tulla with the Royal Scotsman of the 1980s, then a more improvised assembly (cf. page 49). The West Highland terrier emblem denotes Glasgow Eastfield depot. The proposed Glasgow & North Western Railway would have swung west to Inveroran and Blackmount (seen in the distance) in the direction of Kingshouse and Glen Coe.

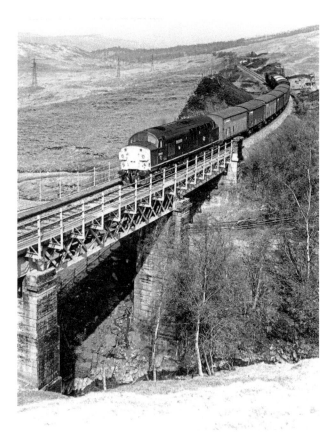

Left: A south-bound Speedlink
crosses Achallader viaduct
in April 1984. The view is up
Strathtulla, towards Crannach
Wood (a relic of Scotland's
ancient pine forests) and
Rannoch Moor. No main road
will be seen again for many
miles. (*Noble*)

Below: With a Class 47 in the
lead and a Class 37 in the rear,
the Royal Scotsman begins
the descent of Strathtulla in
August 2009. On this section, in
July 1894, a torrential summer
thunderstorm washed away the
embankment and a construction
train tumbled into the gap. But
the line opened for traffic a
month later. (*Crawford*)

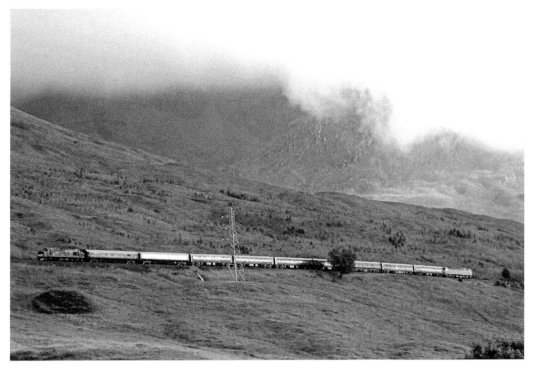

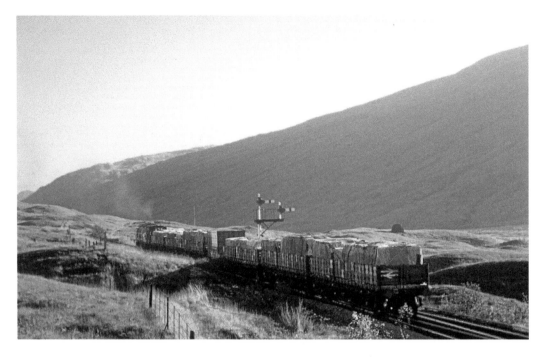

A 1960s pulp-and-paper train heads south from Gorton (Gortan) into Strathtulla. The passing place had just been remodelled and re-signalled, to give through road or 'as required' loop in both directions. Gorton loop was subsequently removed, then restored as a basic maintenance facility.(*Chamney*)

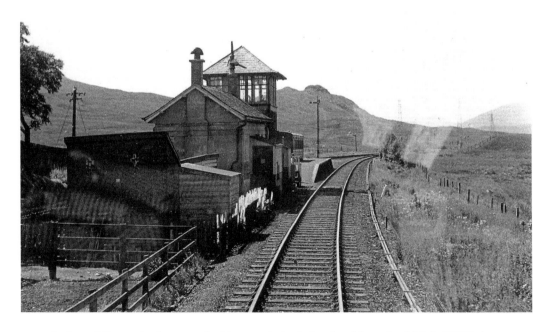

A view of Gorton in the 1950s, looking south, includes the old coach which in LNER days was a school-room for the children of several isolated railway families. The 'lady-teacher' travelled from Bridge of Orchy.

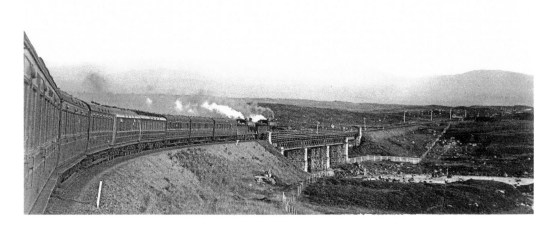

In the heart of Rannoch Moor, 9407 *Glen Beasdale* and 9307 *Glen Nevis*, on an excursion returning to Glasgow, take the curve at the River Gauer in August 1930. (*H. C. Casserley*)

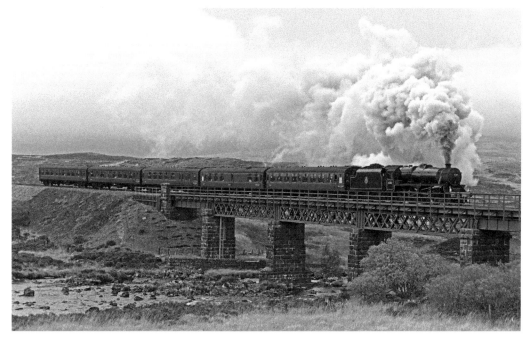

Preserved Black 5 45407 (disguised as 45487) crosses the viaduct in October 2010, southbound with a photographers' chartered train. Tulla Water feeds the westward-flowing River Orchy, but the Gauer runs east from Loch Laidon to Loch Rannoch, in the vast Tay catchment. This time the watershed is lost among sluggish peaty streams. (*Fielding*)

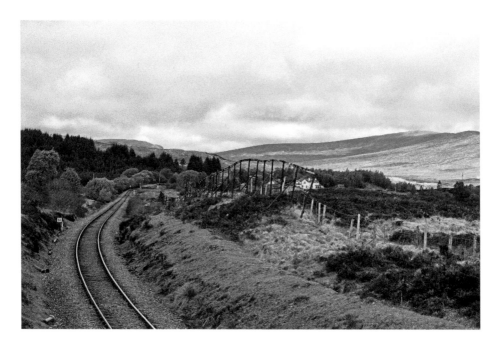

On the southern approach to Rannoch station, the snow fences have deteriorated over many years. When first erected, these barriers were intermittent from Strathfillan to Glen Spean. (*Gray*)

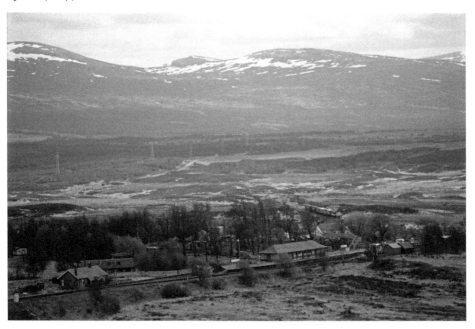

A down freight approaches Rannoch station, where the island platform has footbridge access. Behind the overgrown turntable-pit, the former camping coach eventually housed an angling club. With no turntable between Garelochhead and Fort William and no water column between Bridge of Orchy and Tulloch, winter at once taught lessons, and tables were installed at Crianlarich (see also page 38) and Rannoch. (*Crawford*)

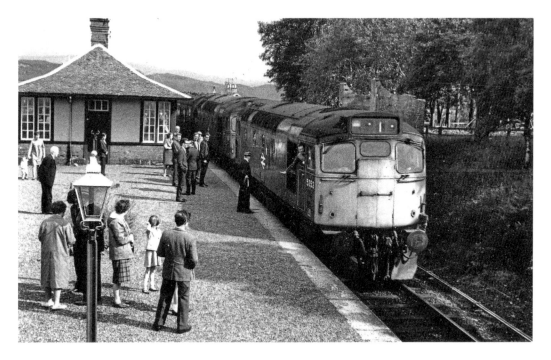

Two BRCWs, with 5352 in the lead, bring an up special into Rannoch (the 'D' prefix was discarded when steam officially ceased). A water tank – note the crumbling piers – was hastily improvised after the line's first winter.

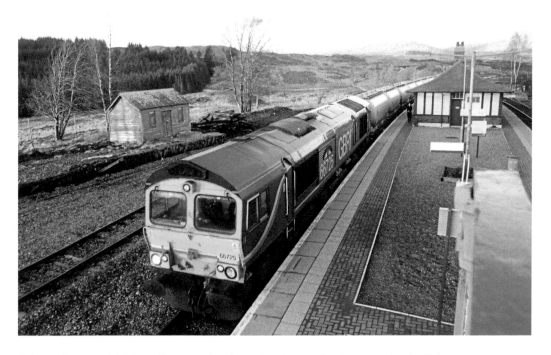

Taking the now 'right-hand' up road, 66-725 heads an alumina empties in February 2011. (*Crawford*)

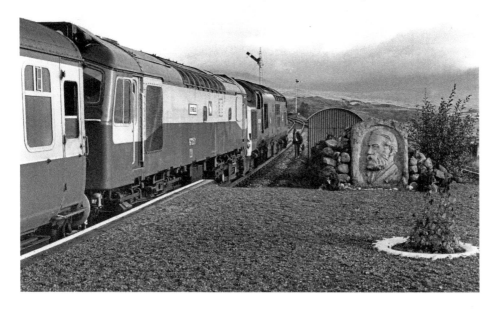

'Ethel' units first appeared on the Sleeper in March 1983. West Highland 37s were not then equipped for electric-heat sleeping cars. The sculpted boulder at the north end of Rannoch station commemorates financier James Renton, whose bridging loan ensured completion of the West Highland, pending Parliamentary authorisation of a larger capital. (*Noble*)

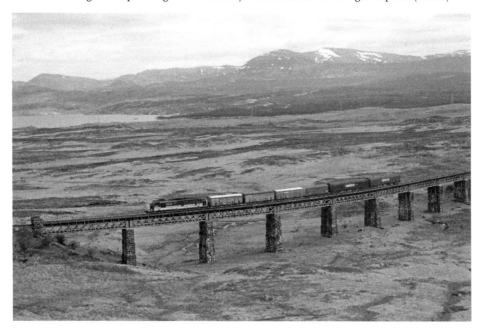

A down freight crosses Rannoch viaduct, longest on the West Highland, in 1991. The Laidon-Rannoch-Tummel valley stretches eastward, with Loch Eigheach at top left. (*Crawford*)

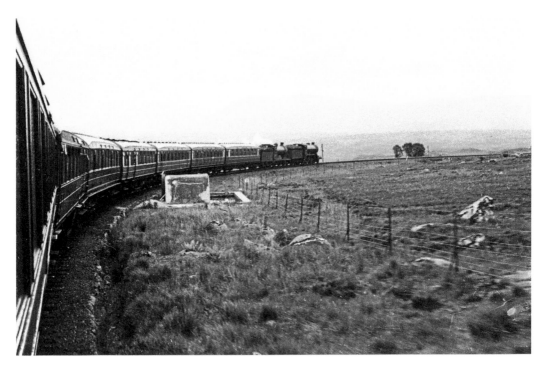

K2 4699 *Loch Laidon* and pilot D34 9307 *Glen Nevis* trace the curves at Cruach, descending towards Rannoch station with a Fort William–Glasgow train in June 1937. The stock is entirely LNER. (*H. C. Casserley*)

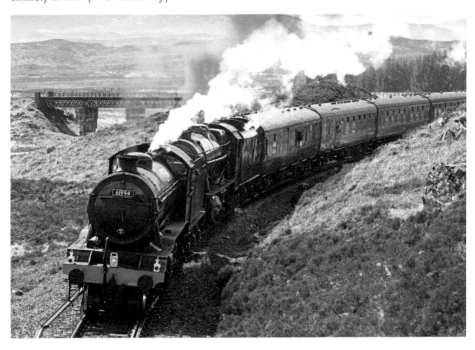

On a down special at Cruach in May 2008, with Rannoch viaduct behind, K4 *The Great Marquess* is paired with ex-LMS 8F 2-8-0, 48151. (*McNab*)

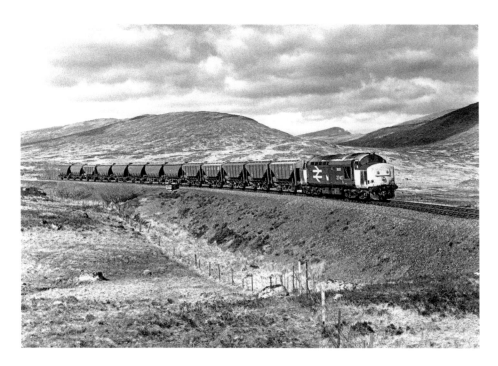

On the descent to Rannoch, in May 1987, is 37-407 *Loch Long*, with alumina empties. Vehicles for this traffic have ranged, through eighty years, from converted grain wagons to the latest tankers. The naming of diesel locomotives, though welcome, has always seemed haphazard. (*Noble*)

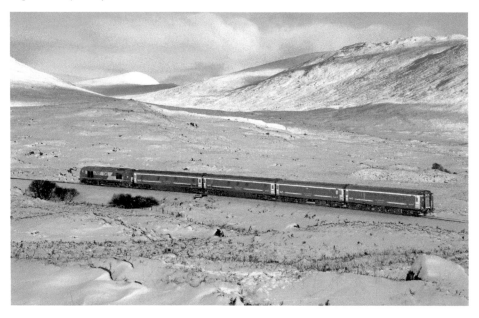

Class 67s are now the regular engines on the Sleeper; Mark 3 stock provides the 'seated accommodation'. In January 2010, 67-007 nears Cruach snow-shed with the down train. Without the Motorail element which for a time enhanced this service, it remains vulnerable to eager cost-savers. (*McNab*)

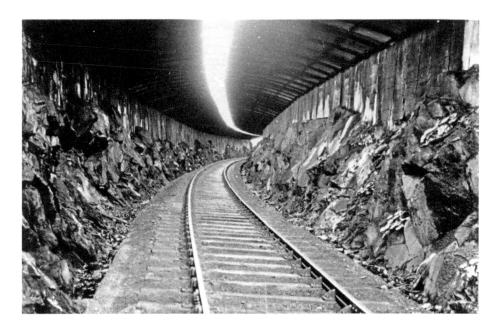

Cruach cutting proved a snow trap. With concrete walls founded on the raw granite, a roof of old rails and corrugated-iron sheeting was added, creating a unique snow-shed. In steam days, the longitudinal centre-section was removed each summer. (*Alsop*)

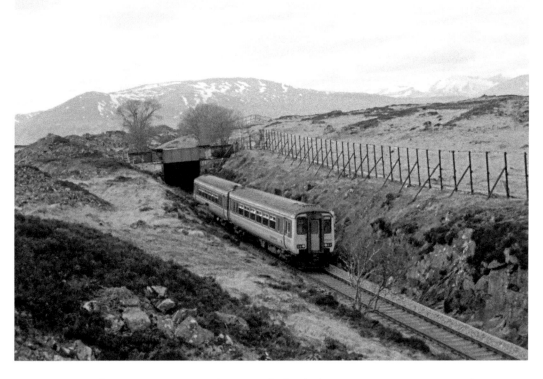

In 1991 a down Sprinter enters the snow-shed, which incorporates an accommodation bridge. (*Crawford*)

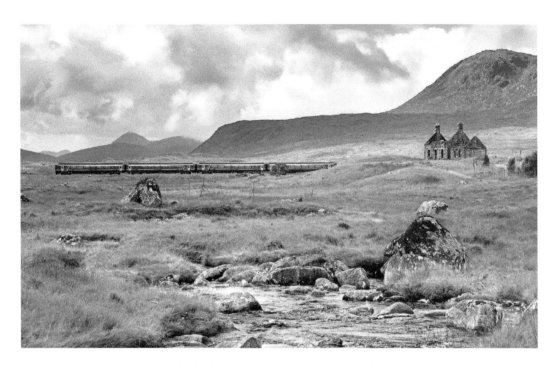

Onwards to Corrour, on the highest stretch of Rannoch Moor, the watershed is crossed for the final time; here the streams drain west to Blackwater reservoir and Kinlochleven. A two-set Sprinter passes Lubnaclach in August 2009. Class 156 DMUs have worked on the West Highland for almost a quarter-century. (*McNab*)

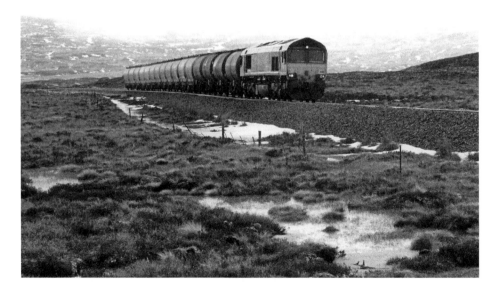

A Class 66, with oil and alumina for Fort William, approaches Corrour. Winter travellers frequently encounter not 'white-out' but clinging mist and wet snow. In the melt after a testing winter the moorland is snow-mottled for weeks on end. (*Crawford*)

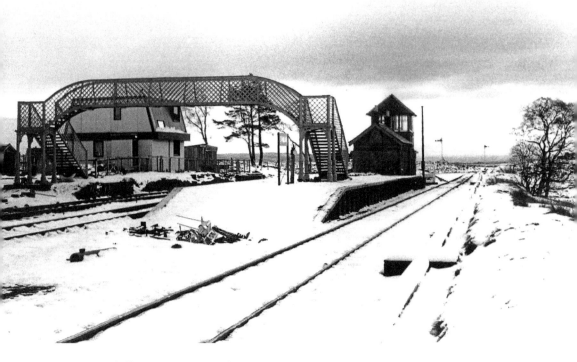

Corrour is decidedly wintry in November 1982. (*Stevenson*)

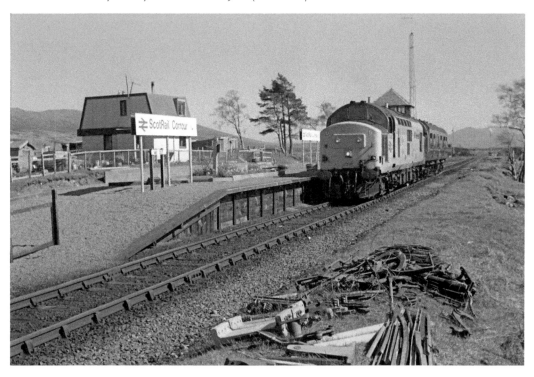

By contrast, Ewan Crawford has found a spring day in 1990, when a Class 37 waits with an inspection saloon. In the last years of traditional token-working, the signalman's family occupied a much-needed modern house.

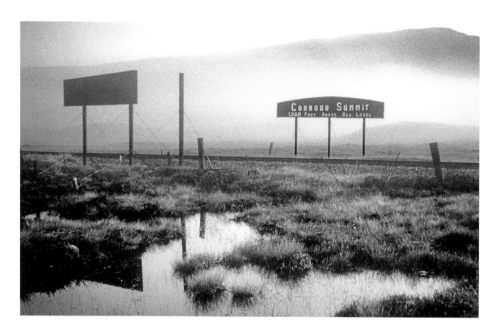

The West Highland's ultimate summit, superior to Ais Gill on the Settle & Carlisle line but a little inferior to Drumochter on the Highland, is immediately north of Corrour station. These late twentieth century sign boards have since been replaced. (*Chamney*)

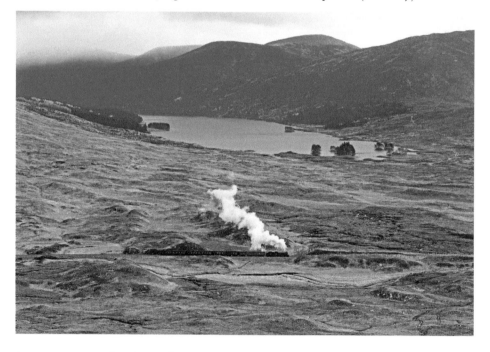

In a panorama embracing Loch Ossian, preserved K1 61994 nears the summit on an end-of-season journey to Carnforth, after summer service on the Mallaig Extension. Corrour Lodge lies hidden at top-left. The ancient paths and bridle ways of this district, which in earlier centuries gave east–west communication into Lochaber, now serve today's outdoor activities. (*Fielding*)

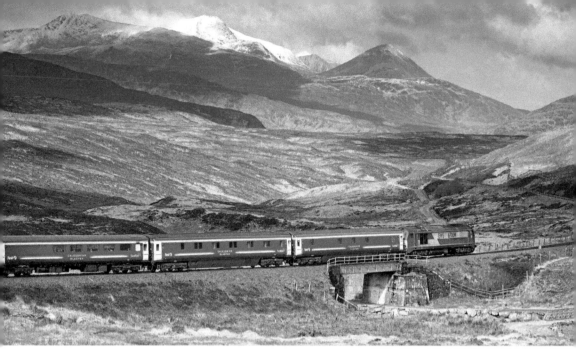

Passing Lebruaridh, the down Sleeper begins the descent to Loch Treig and Glen Spean in May 2012, with the Ben Nevis range in the distance. (*McNab*)

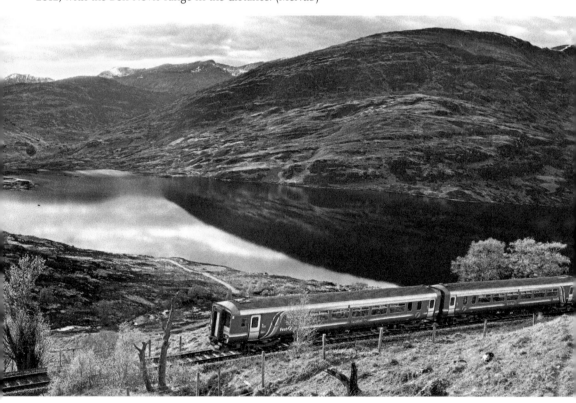

A southbound Sprinter climbs past Lochtreighead on a still afternoon in May 2009. (*MacNab*)

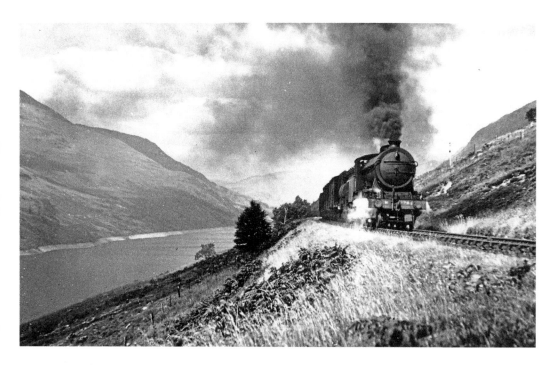

On the long ascent by Loch Treig, in August 1947, K2 1786, working hard, heads an up goods.

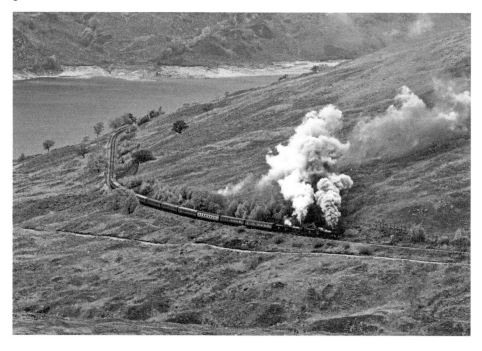

With an eleven-coach SRPS special (see also page 46), Black 5s 44871 and 45407 turn away from Loch Treig, tackling the final miles to Corrour in October 2012. The interwar Lochaber Power Scheme linked Loch Laggan and Loch Treig as reservoirs, with unsightly consequences when water levels fall. (*Fielding*)

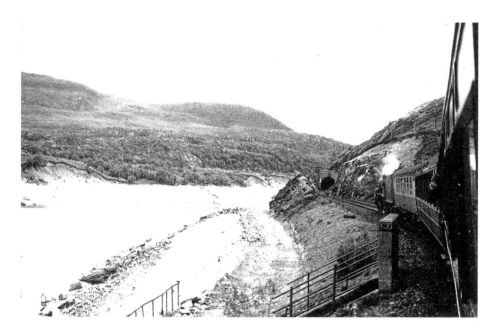

Realigned to accommodate the Treig dam, the West Highland gained a short tunnel (see also page 31). With the old track-bed visible on the left, the 'K4 farewell' excursion in June 1960, pulled by 61995 *Cameron of Lochiel*, takes the deviation. (*H. C. Casserley*)

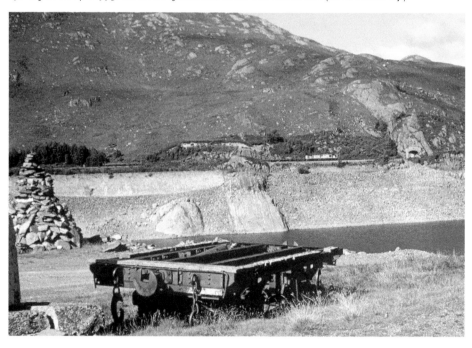

A Class 37 with freight empties approaches the Treig tunnel, seen from the opposite bank. The narrow-gauge wagon is a relic of a once extensive system, dating from construction of the Power Scheme which has since sustained the aluminium smelter at Fort William. The British Aluminium Company retained the narrow-gauge line to Loch Treig until the 1960s. (*Chamney*)

On a rainy evening in June 2005, a Class 66 takes an up aluminium-plus-alumina empties past the Treig dam. (*Crawford*)

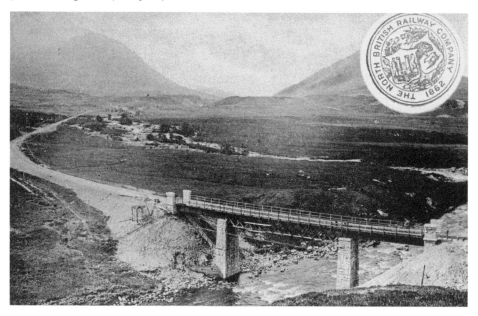

Approaching Tulloch, the West Highland swings south-west for Fort William. This decisive turn, easily missed after the disorienting miles across Rannoch Moor, is seen in an early photograph of Tulloch (Laggan) viaduct, looking back to Fersit and Loch Treig. While the Laggan and Treig dams were building, sidings and a temporary platform were put in at Fersit, where a ballast siding dated back to the building of the line. (*Alsop*)

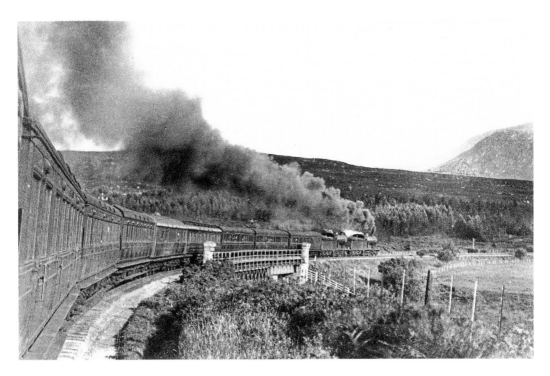

Across Tulloch viaduct, *Glen Beasdale* and *Glen Nevis* (see also page 56) attack the gradient together in August 1930. (*H. C. Casserley*)

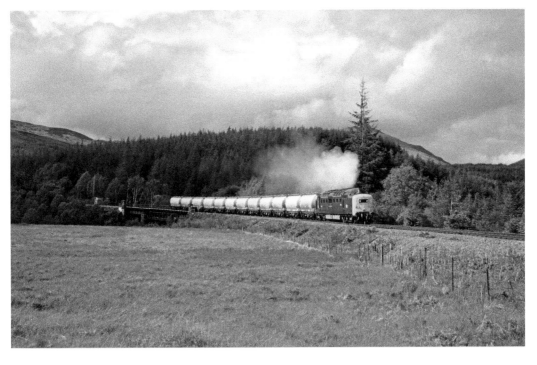

In May 2011 preserved Deltic Class 55-022 *Royal Scots Grey*, temporarily employed on alumina traffic, crosses Tulloch viaduct. (*Henshaw*)

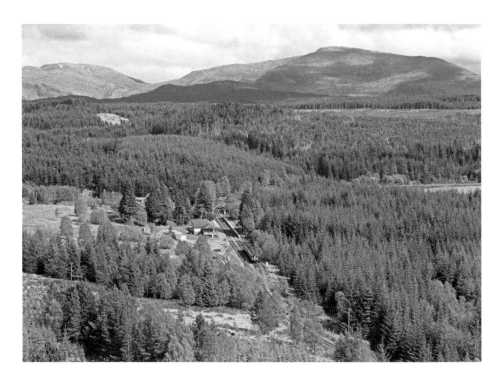

Mark Fielding captures that decisive change of direction (see page 69), with today's tree-cover (which hides the viaduct) much in evidence. In May 2011, a down Sprinter leaves Tulloch where 'left-hand' running continues. The station building has been redeveloped as a hostel. (See also page 51)

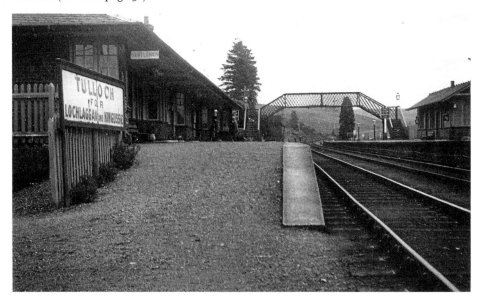

The stations in Brae Lochaber – Inverlair (renamed Tulloch to placate the landlord), Roy Bridge and Spean Bridge – began 'side-platform', with a chalet-range on the up side. The Fort William–Kingussie coach service was adjusted to connect with the trains at Tulloch. A rail link by Loch Laggan to the Highland Railway was a possibility.

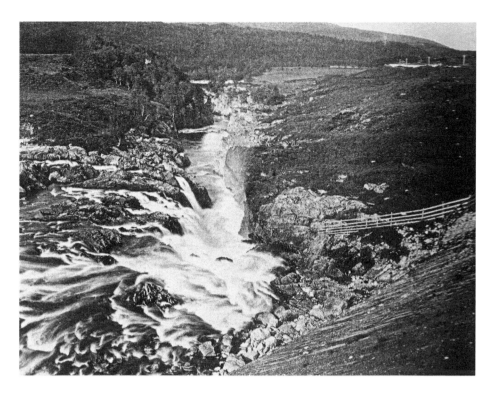

With Loch Laggan and Loch Treig tapped for hydro-power, the River Spean is much reduced – though spates after heavy rain are now all the more impressive. An early photograph shows Inverlair Falls, west of Tulloch, as they once were (the railway embankment is at bottom right; the line reappears at top right).

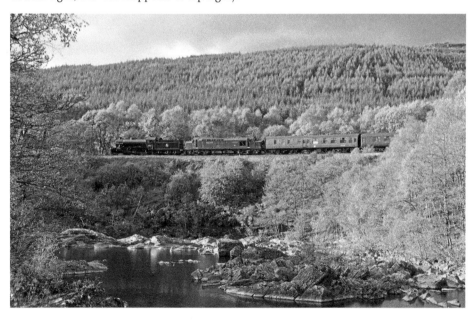

In May 2011, the Cathedrals Explorer special rounds the curve at the Falls, behind *The Great Marquess* and 37-676 *Loch Rannoch*, the latter replacing a failed Black 5. (*Fielding*)

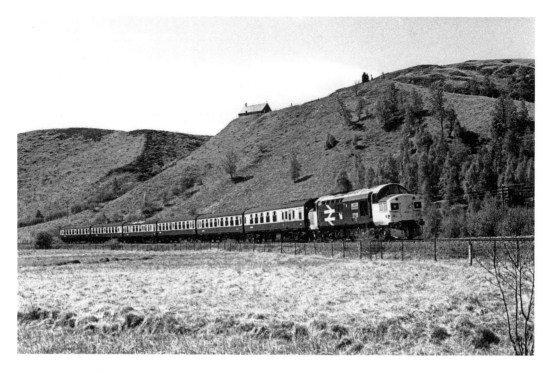

37-111 *Loch Eil Outward Bound* heads an up passenger service at Achluachrach, Glen Spean, in May 1988: the rake is entirely grey and blue Mark 1 stock. Killachoireil chapel is perched above road and railway. (*Noble*)

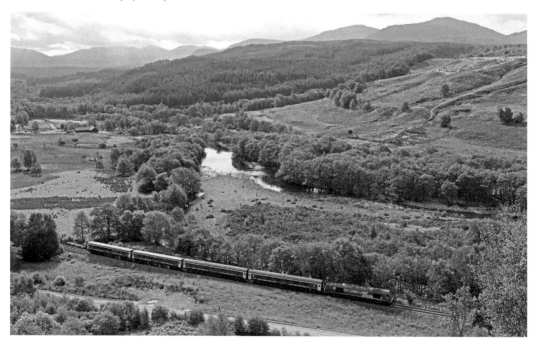

Seen from the chapel, the down Sleeper runs towards Monessie in July 2011, behind 67-004. (*Fielding*)

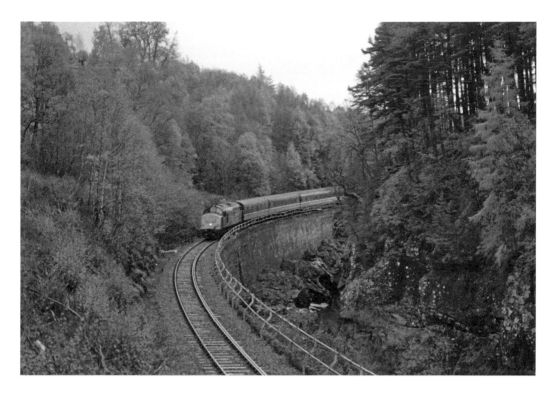

Monessie Gorge featured prominently in early tourist literature extolling the West Highland. A 37 follows the defile with the down Sleeper. The depleted River Spean reveals age-old, tortured rocks.(*Crawford*)

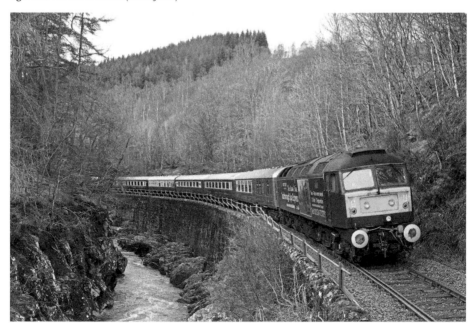

A Class 47 heads the Winter West Highland Statesman (a special returning to Nottingham) in March 2012. (*Fielding*)

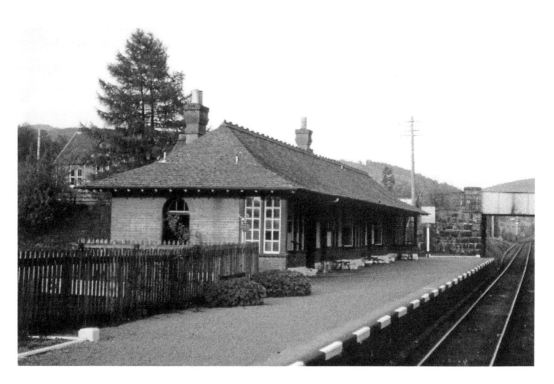

Roy Bridge in BR days appears little altered – though the up starter signal is no longer 'lower quadrant' on a lattice post. (*Stevenson*)

Only the old down platform remains today, accessed from the same overbridge. The sign between the lamp posts details destinations in both directions (cf. page 51). (*Furnevel*)

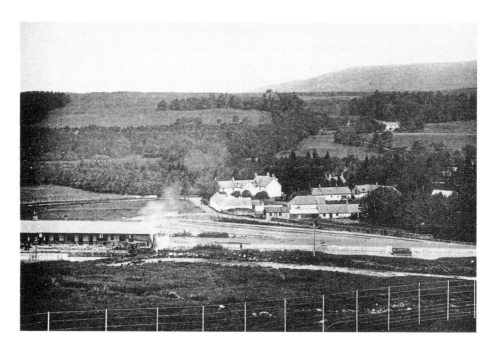

A Lucas & Aird 'pug' stands at Spean Bridge. Opening Day is approaching, and the Board of Trade, though indulgent over unfinished passenger facilities, will insist that signalling be in order. Only the foundations of the signal box (right) are in place and completion will be touch and go... The sidings were intended primarily for livestock. Droves had traditionally concentrated at nearby High Bridge, and 'walking' to market was still common.

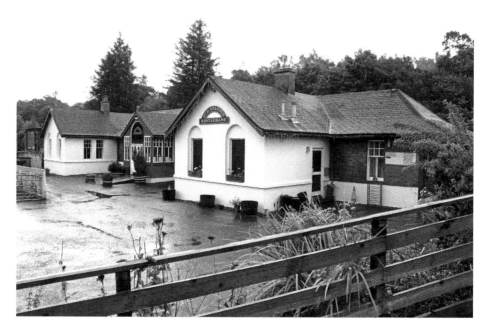

The chalet-range has become a restaurant – though this 'Old Station' (sic) is still very much in business The ScotRail sign (platform information, for 'right-hand' running) is scarcely prominent. (*Furnevel*)

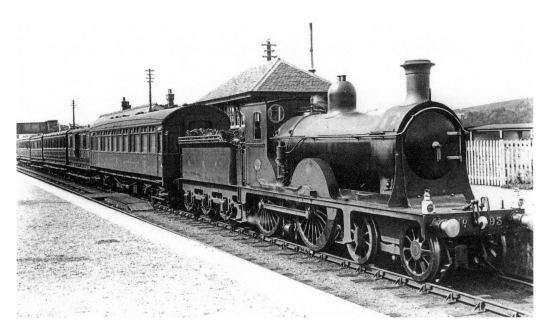

North British Abbotsford rebuild, Class M, 493 (once *Netherby*) pauses at Spean Bridge. A North Eastern coach outshines North British stock. The Abbotsfords surpassed the under-powered West Highland Bogies; despite their 6 foot 6 inch driving wheels, they proved more than stop-gaps and were not at once displaced by Intermediates and Glens. (*Lynn*)

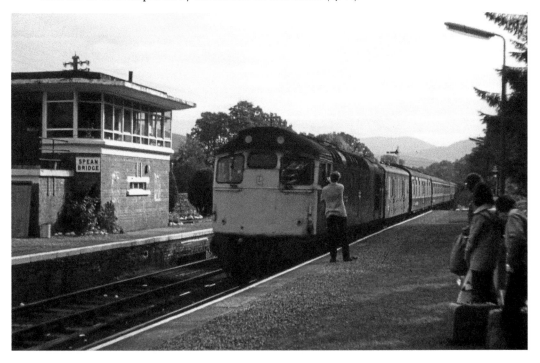

Traditionally brisk tablet-exchange continued in diesel days. Spean Bridge signal box was enlarged to accommodate the Invergarry & Fort Augustus and then replaced, after fire damage, by the LNER. (*Frank Spaven Collection, courtesy David Spaven*)

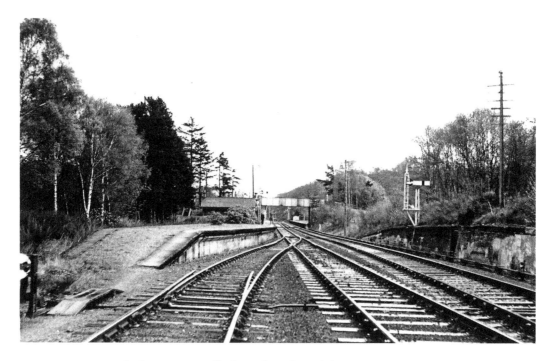

A 1950s view, looking east, recalls how the relics of the once-elaborate junction layout at Spean Bridge disappeared little by little. The junction faced Glasgow: through trains between Fort William and Fort Augustus reversed. (*Stevenson*)

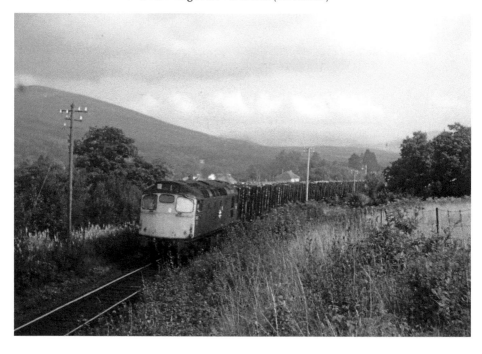

By 1971, BRCW Sulzers (Class 27) were to be expected on every West Highland turn: the timber train heads away from Spean Bridge towards the minor summit at Auchindaul before dropping finally to Fort William. (*Frank Spaven Collection, courtesy David Spaven*)

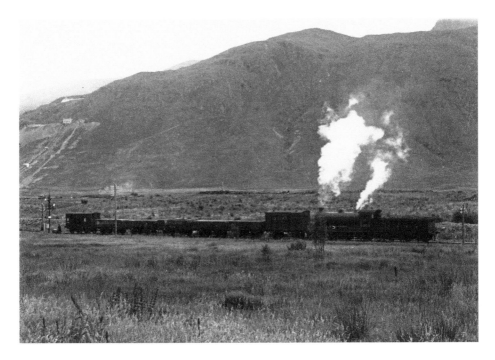

In the early 1930s, LNER Class J37 9303 (ex-North British Class S) shunts at the new connection for Fort William's aluminium smelter. As elsewhere on the former North British system, this class did occasional passenger turns. The penstocks (top left) terminate the 15-mile tunnel from Loch Treig; from the smelter power-house the water escapes, under the railway, into the River Lochy. (*Rear*)

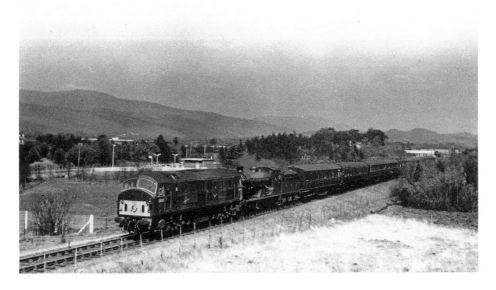

Approaching the same spot, in June 1963, are NBL Type 2 and restored NBR 256 *Glen Douglas* on the farewell-to-steam Jacobite special. The J37 partnering *Glen Douglas* had failed at Rannoch. (*C. Lawson-Kerr*)

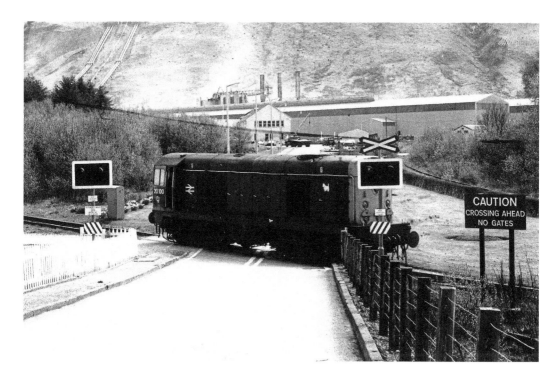

In 1985, at the 'BA branch' level crossing, 20-100 sports an Eastfield 'Westie'. In the earliest diesel days, EE Type 2s piloted passenger trains on the West Highland proper and did summer passenger work on the Extension; latterly a 20, in effect spare engine at Fort William, earned its keep on local 'trips' or by deputising for a Class 08 shunter. (*MacDonald*)

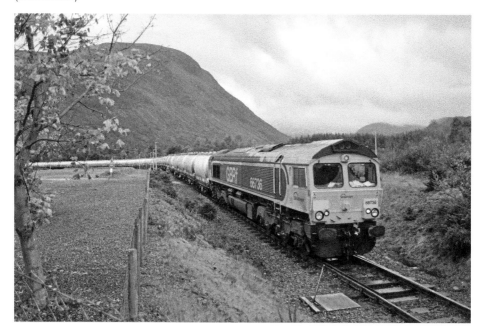

In October 2011 66-736 shunts at the smelter, now modernised by Alcan. (*Henshaw*)

Right: 37-028 brings a Glasgow train into Fort William, past Mallaig Junction, in August 1983. The over-bridge carried the British Aluminium Company's narrow gauge railway, linking deep-water pier and smelter, and built more solidly than the 'wild west' track onwards to Loch Treig (see also page 68). (*Noble*)

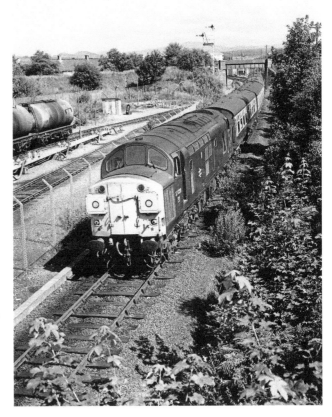

Below: The West Highland as authorised in 1889 would have entered Fort William along the River Lochy. The amended layout gave sidings to Ben Nevis distillery (at Lochy Bridge) and Nevis Distillery (in the town). At the latter, a gable was skewed to accommodate the line. Today's station is situated beyond the curve. (*Johnstone*)

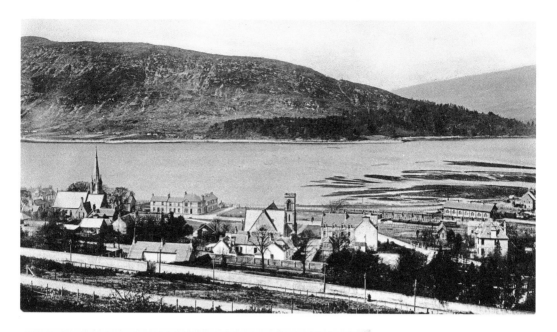

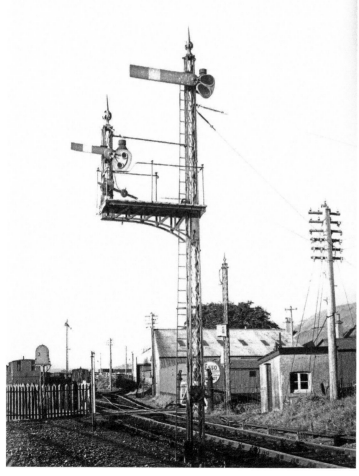

Above: When the West Highland was new ... This photograph of Fort William shows (left to right) the North British Company tenements; the level crossing to the yard; the original goods shed, and, at the old fort, a barracks earlier converted to domestic use and retained until *c.* 1930. (*Alsop*)

Left: A 1930s photograph just catches the livestock loading bank (an early addition to the yard at the old fort) and the door of the later LNER goods shed; the level crossing straddles the siding points. Here had stood, on the south side of the main line, the temporary platform for Opening Day in 1894; the same tree appears (see also page 10). (*Rear*)

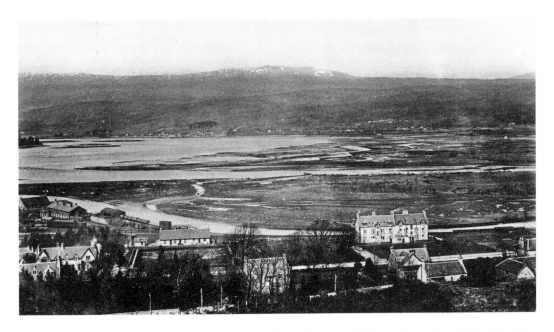

Complementing the top image opposite, another photograph shows the engine shed and coaling stage, within the walls of the old fort. The River Nevis follows its original course; the BA railway and pier are yet to come; and the Airds (An Aird) is a tidal wasteland between the Lochy and Nevis estuaries. The private tenement (centre right) has remained; it overlooks today's station. (*Alsop*)

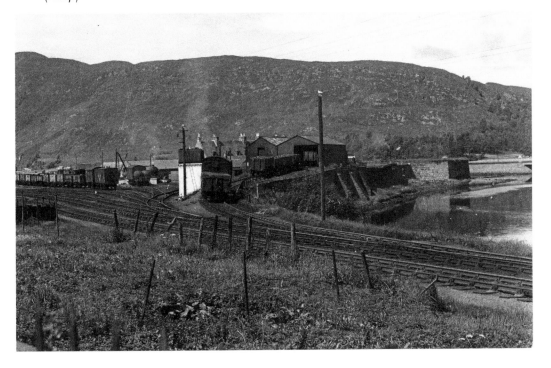

Another 1930s view shows the yard and shed, just before the LNER finally demolished the old barracks and installed a modern turntable. (*Rear*)

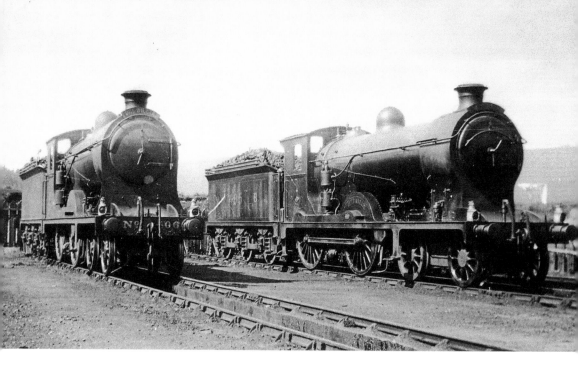

In North British livery, 406 *Glen Croe* and 495 *Glen Mallie* rest behind Fort William shed. The entire class, like 495, eventually lost their smoke-box wing plates. Curved destination boards were a North British feature (see also page 16). (*Lynn*)

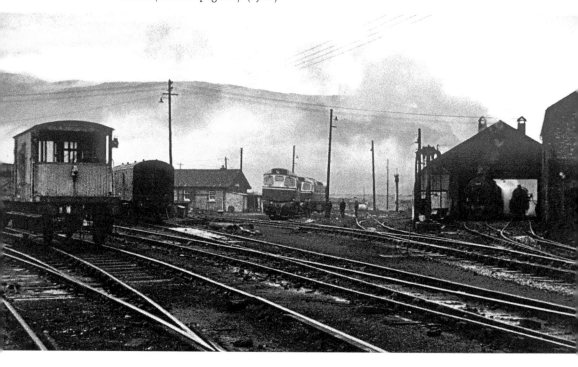

In October 1961 two BRCW Type 2s, in green with white window-surrounds and no garish warning panels, share the depot with the Black 5s and K1s which would see steam out. (*Chamney*)

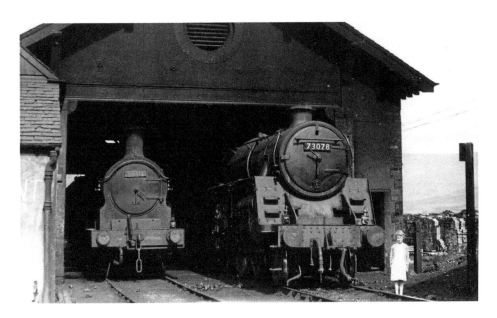

Standard 5 73078 and J36 65313 were well-known at Fort William. The little girl has not been identified. When quiet, the shed was unofficially open to all-comers. Sunday-afternoon walks often ended there – a Scottish habit in smaller railway towns. (*C. Lawson-Kerr*)

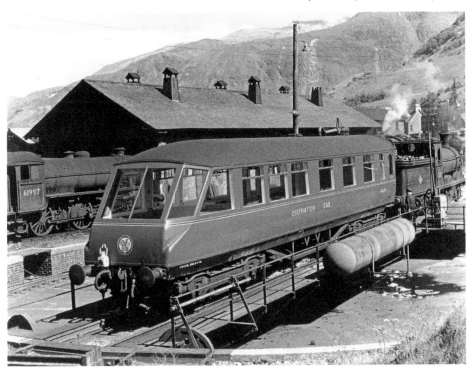

From 1956 the ex-LNER Coronation observation cars did summer service, first on the Extension, then on the West Highland proper. Their 'beaver tails' were soon modified for an all-round view. The duty pilot at Fort William detached them, took them to and from the turntable, and repositioned them at the rear of their trains. (*Glenfinnan Station Museum Trust*)

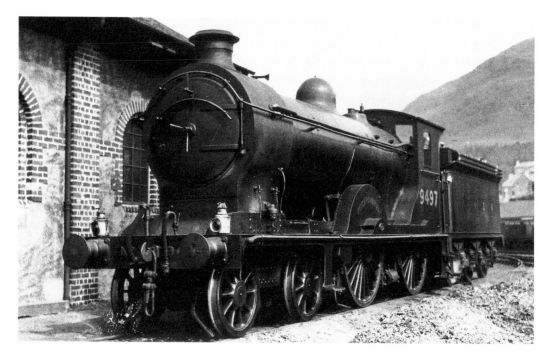

LNER Scott D30 9497 *Peter Poundtext* (North British Class J) visits Fort William shed in the 1930s – probably on a Sunday excursion from Glasgow. The 6 foot 6 inch Scotts never became 'West Highland engines' like the 6 foot Glens, but larger driving wheels were not a disqualification. (*Lynn*)

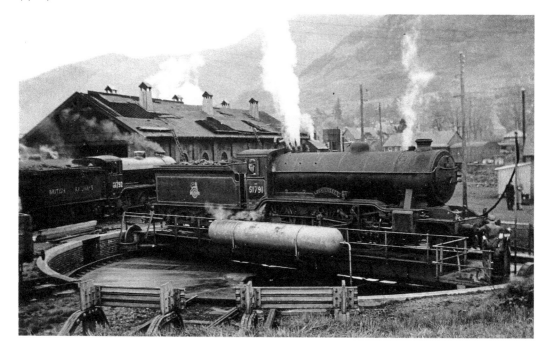

In 1952, the K2 Class was still well-represented. They were 'West Highland engines' by adoption. Like 61792 here, some continued nameless. (*H. C. Casserley*)

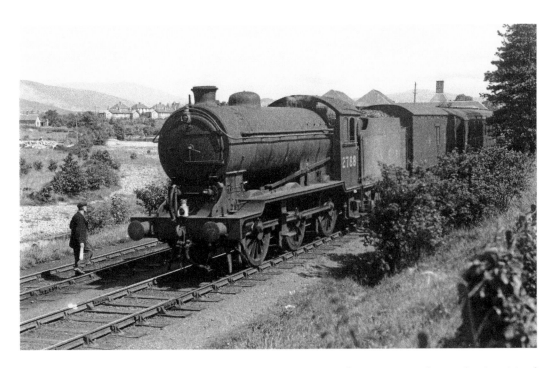

Though eventually supplanted by mixed-traffic 2-6-0s and 4-6-0s, LNER-designed 0-6-0s joined the ex-North British stud on the West Highland. J39 2788 is seen east of Fort William yard. In the background are Nevis Distillery and, across the Airds, the houses of Inverlochy, British Aluminium's 'company village'. (*Rear*)

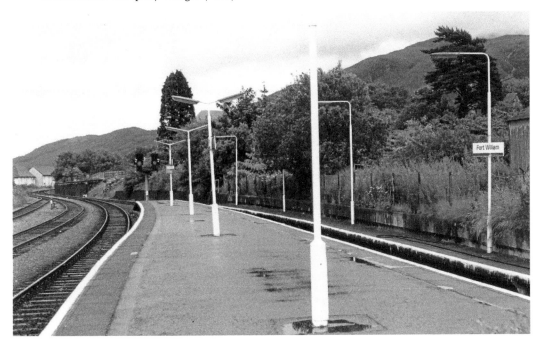

At almost the same location are the platform end and starting signals of today's Fort William station, opened in 1975. (*Stevenson*)

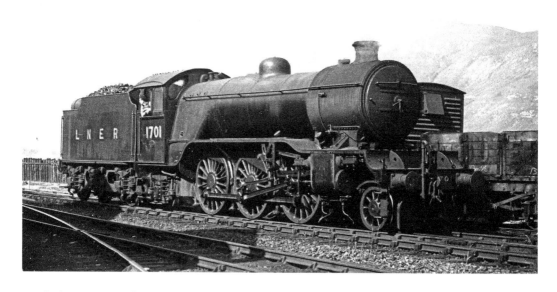

Ready for passenger duty, V4 1701 exits Fort William yard tender-first and takes the main line, in late LNER days. It will go down the seawall, past level crossing and signal box, to the station, where its train waits. (*Stevenson*)

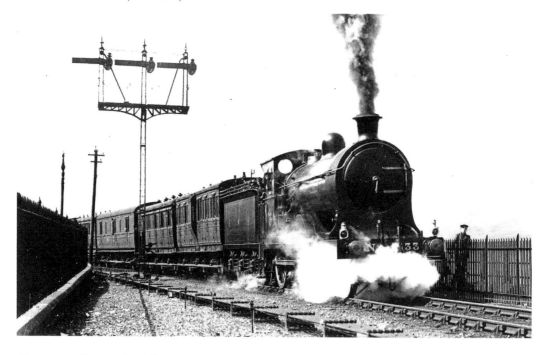

Glasgow–Mallaig and Mallaig–Glasgow trains reversed, changed engines and re-marshalled at Fort William station. The relieving locomotive shunted in and out, attaching or detaching vehicles. With these manoeuvres completed, North British 'Intermediate' Class K 333 departs for Mallaig. The rake includes two six-wheel coaches besides bogie stock. (*Lynn*)

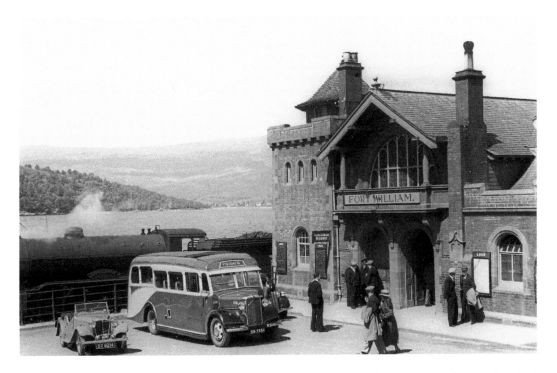

In this interwar scene, a David MacBrayne bus waits outside the station, while K2 4692 *Loch Shiel* waits release to the shed. The platform road where the engine stands continued across the pierhead to the former distillery pier, purchased by the West Highland Company. (*Lens*)

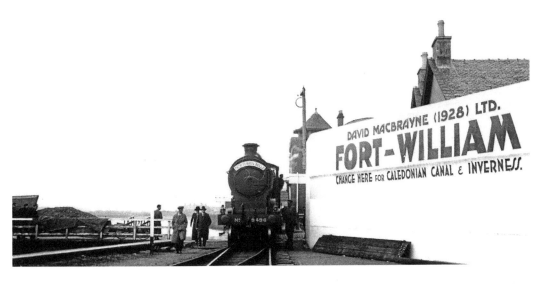

The 'day' and 'night' portions of the Northern Belle each required a pair of Glens. Leading engine 9496 *Glen Moidart* has overshot the station, blocking the town pier. By overshooting, lengthy incoming trains cleared the points at the station throat, where the three platform roads converged, and relieving engines could begin shunting. (*Lens*)

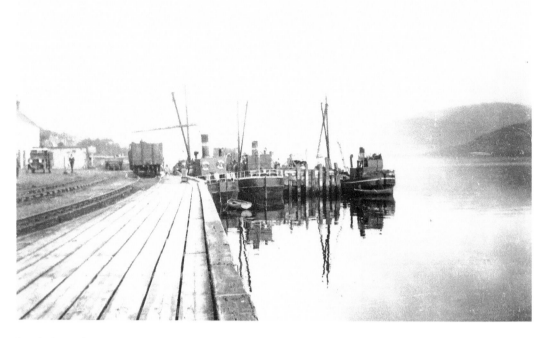

Until the railway came, Fort William's distillery traffic went by sea. The railway pier (as it became) was still drawing revenue from coastal shipping in the 1930s. A four-coach set could be stabled between town pier and railway pier. (*H. C. Casserley*)

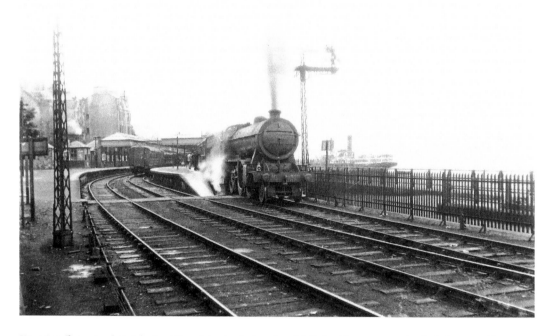

K2 4699 (later *Loch Laidon*), with original cab, heads a Mallaig–Glasgow service in July 1931. The steamer at the town pier is MacBrayne's *Iona*. Though the platforms were a little lengthened in 1895–6, the loch-side layout was, and remained, severely restricted. (*H. C. Casserley*)

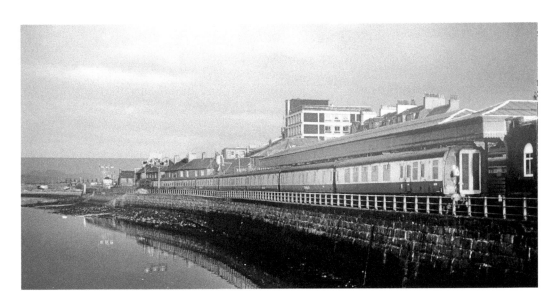

An NBL Type 2 heads the up Sleeper – afternoon Mallaig–Glasgow plus London portion. This Mark 1 rake exemplifies the winter service in the mid-1960s – two compartment brakes, composite and buffet-restaurant car, out and back from Glasgow; two sleeping cars and brake-composite, out and back from Kings Cross. Fort William signal box is along the sea-wall. (*Chamney*)

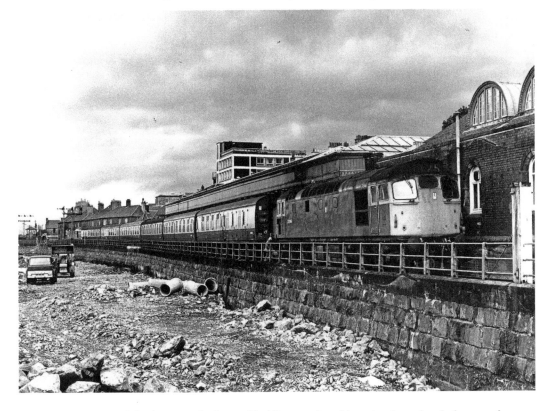

Construction of the bypass which would obliterate the old station has already begun when 27-106, up from Mallaig, stands uncoupled from the morning train for Glasgow c. 1970. (*Noble*)

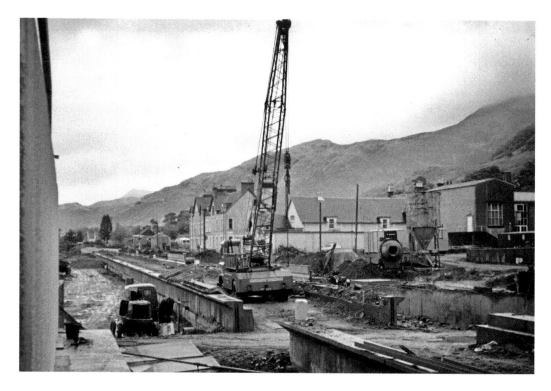

Fort William's new station takes shape, towards the end of 1973. (*Chamney*)

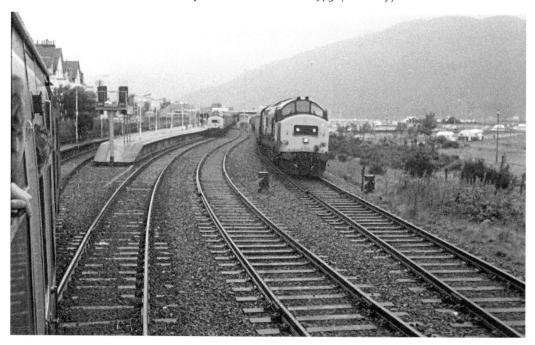

During the first decade of the new station, Class 27s were displaced by 37s. From an arriving train, 37-hauled, Ewan Crawford captures two more of this class. The Airds, though reclaimed, are not yet developed (a variety of buildings and activities now occupy the area).

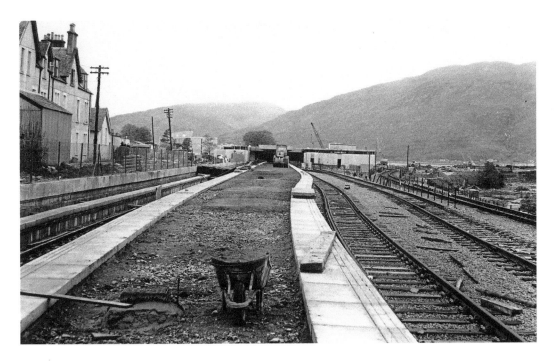

In May 1975 the old yard and shed have gone, but a tenuous track – more or less the original main line – still leads past all the upheaval and down the sea-wall to the old station, during its last weeks of life. (*Stevenson*)

Sprinters stand in the new station. The arrival and departure of DMUs, which simply change direction, seems a world away from the topping-and-tailing which characterised the station at the pierhead. (*Furnevel*)

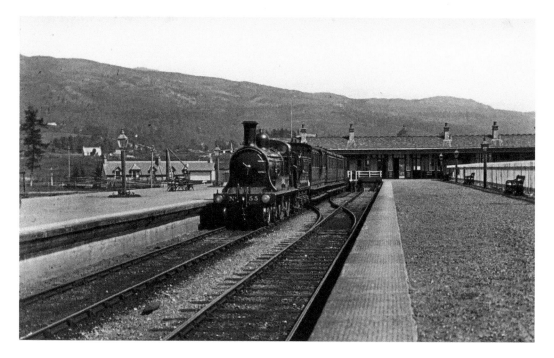

With West Highland Bogie 55 on an up train, the North British are in possession at Fort Augustus, where traffic never justified so lavish a station. The signal (left) protects the swing bridge on the Caledonian Canal, whence the line reached Fort Augustus Pier on Loch Ness: this last section was abandoned early. (*Alsop*)

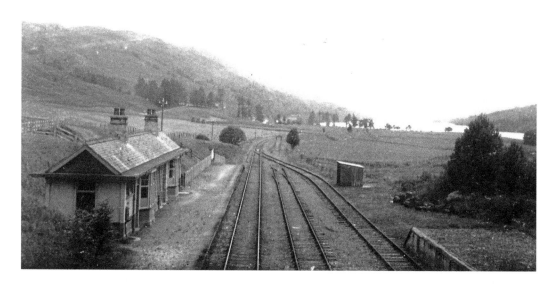

Aberchalder station is seen after closure, looking south to Loch Oich. (*Lynn*)

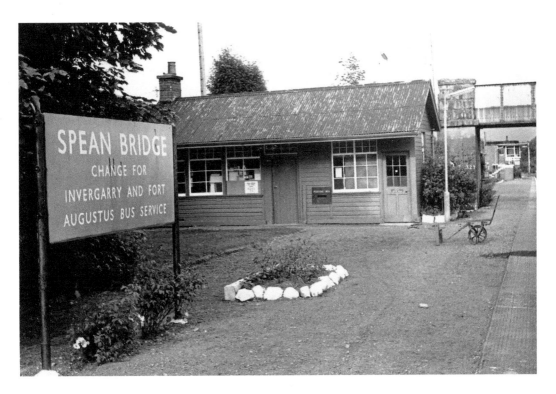

While the Fort Augustus line was building, relations with the North British were tetchy; one result was the separate I&FA building at Spean Bridge (see also page 78). The BR Scottish Region sign is a sad reminder of a venture part plucky, part misguided. (*Noble*)

Resurrection – as heritage and information centre? During 2012-3, the Invergarry Station Trust have made a hopeful start. (*C. Ellice*)

Acknowledgements

I am grateful to many – for exchange of information, advice, photographic expeditions and much else: my wife Christine, grandson Dean, and old friend Alan Johnstone; railway historian Harry Knox; John Barnes, Hege Hernes and Malcolm Poole, my fellow trustees at Glenfinnan; Doug Carmichael, Fraser MacDonald, Norman McNab and Duncan Wilson (Friends of the West Highland Lines); Donald Cattanach, Bill Lynn, Brian MacDonald, Ed McKenna, Allan Rodgers and Douglas Yuill (North British Railway Study Group); and Hamish Stevenson (Scottish Railway Preservation Society). All who provided photographs have my special thanks – not least Ewan Crawford: busy on his complementary 'Through Time' Callander & Oban book, he has given generous help and support.

JMcG
March 2013

Photos: Alsop Collection; D. Carmichael; H. C. and R. M. Casserley; J. Chamney; E. Crawford; J. Currie; M. Fielding; J. Furnevel; J. Gray; Hennigan Collection (courtesy R. W. Lynn); I. Henshaw; Invergarry Station Preservation Society (C. Ellice); A. Johnstone; Lens of Sutton; R. W. Lynn; M. Lyons; M. MacDonald; Christine McGregor; N. McNab; Mitchell Library, Glasgow (C. Lawson-Kerr Collection); T. Noble; W. Rear Collection; D. Spaven; J. D. Stevenson Collection; B. Stone; also author's collection, or unidentified.